THE OTHER CANYON

by
Patricia Geary

GORSKY PRESS
COCOA BEACH • FLORIDA
2002

The Other Canyon

copyright © Patricia Geary, 2001

Cover artwork: *A Thrilling Time Ahead* by Penny McElroy

All interior artwork by Penny McElroy:
Page 14: *Look A Little Nearer*
Page 42: *A Bridge*
Page 68: *The Spiral of This World*
Page 92: *A New Chapter*
Page 110: *Cave Voices*

Cover design by Sean Carswell

ISBN 0-966-818539
Library of Congress Control Number: 2001135392

gorsky press
P.O. Box 320504
Cocoa Beach, FL 32932
www.gorskypress.com

Printed in the United States by:
Morris Publishing
3212 East Highway 30
Kearney, NE 68847
1-800-650-7888

For Don Heiney

The way of heaven benefits and does not harm;
The way of the sage is bountiful
And does not contend.

—Lao Tzu

Carla turns on the kitchen tap and fills her large, square-cut crystal glass, so excellent for grounding. The water twirls aimlessly, its cargo of dubious chemicals and unidentifiable organic matters held in perpetual suspension, foreign substances which will never be assimilated. Or so you hope. She takes the oven mitt off her right hand and touches the sides of the glass: the energy level is strangely frenetic this morning. But probably not dangerous. Cautiously, her lips touch the edge of the goblet, tip the rim so the lukewarm water slides down her throat, smooth and odd as oysters.

"Shit!" She spits her mouthful into the sink.

The water is unusually bad today.

Something is up.

Right on cue, the teakettle whistles, and that presents another problem. The tap water is in the kettle, she should have used the bottled stuff. But things have been okay for months, no issues or disturbances. There you are: take things for granted and they get you. Boy, do they get you.

Nothing to do but empty the kettle and boil again with the bottled stuff. Take a shower in the meantime.

The shower, of course, presents another set of problems.

Carla puts the safe water on the stove and walks into her gleamingly white bathroom. Like a hospital, white gives her the illusion of sterility and control. Efficiently, she dons her white bath socks, slips off her terrycloth robe, gathers her fine blond hair into the shower cap, and slides her hands into the bath gloves. When the water jolts on, the funny smell is immediately evident, sizzling with this bizarre underodor.

Carla pauses, debating her dilemma. If she steps inside, who knows what strange wave may take her? But if she doesn't shower, then she'll be repelled with herself all day, feel her skin shift slightly with its residue of body oils, its coagulating essences. Her pores will clog. Everything will be trapped inside her...

Resolutely, her hands part the white curtain, and she enters the stall. At first touch, her protected system registers shock. This is not her imagination; something is very different today.

Usually, her morning shower is a pleasant way of checking in with her world, a sort of aquatic e-mail connecting her with the vast plumbing network of Newport Beach: the water's conductivity allows it to transmit essential greetings from each house, the luminous vibration of synthesis.

But not today. Whatever is different, unexpected, jolts her skin with its off-key melody.

Never mind, just get clean. Pour the Dr. Bronner's peppermint soap onto the loofah and scrub away the night's subtle grease. Don't linger, the

shower is not sensually pleasing right now. But you can handle it; you are tougher than you appear. Step out onto the white sheepskin rug and swathe your body in the pristine bathsheet, soft as cream.

Finished. Now you may exhale.

Towel draped into a toga, hair free, she removes her bath socks and gloves, strolls back into the kitchen to drip the coffee. Freshly ground French roast. Putting the oven mitt on her right hand, she opens the sliding glass door and steps out onto the patio. Fog. Typical of June. The pots of flowers glow peculiarly red and yellow against their misty backdrop. Snail tracks criss-cross the concrete, ghostly messages, but if you follow them to apprehend the snails, the tracks simply end in the middle of nowhere, as though the creatures had dematerialized or knew the secrets of Indian rope tricks.

After a brief inspection, Carla is satisfied for the moment that no snails, slugs, or caterpillars are gnawing away at her primroses. She sips her coffee from a heavy white mug. Returning inside, she drapes herself in thin linen layers, for she has learned the hard way that flax is the most effective insulator. To her ensemble, which resembles to the untrained eye the simple, conventional garments of a pretty blonde, she adds her platinum chains: a thick one around the neck and thin ones around each wrist and ankle.

On her way out the door, she notices that one volume of the Britannica has fallen from its proper slot; the pages are open to a map, brown and yellow and green. Mostly brown. She knows this is not an accident, and yet she is running late. Significance will have to wait.

Outside, the fog hangs over the beach like smoke in the living room after a party. Blood orange impatiens, lobelia blue as veins, calendula the yellow of full, rising moons.

Because she has left her driving gloves in the car, and today seems to demand caution, Carla must maneuver carefully. She extracts the platinum key chain, soothing as fine cognac, from her purse and delicately unlocks the door of her white diesel Mercedes. It is an old car, for no one else these days can be bothered to track down this purer, less aggressive fuel. Merely by touching the lock with the key chain, Carla can tap into the energy field and be grateful that no dubious persons have bumped into her car during the night. Some days the jolt is unnerving, but perhaps today will turn out benign, after all, and she will be spared the migraine so often caused by over-exposure due to carelessness.

As soon as she climbs into her vehicle, she opens the glove compartment and takes out her gloves. The soft leather gentles down like a salve, an enchanted unguent. At first touch, the engine cranks into life, and soon they are tooling through the foggy morning streets, the quaint beach houses and the tiny, expensive shops nestled along Pacific Coast Highway. Oddly, there are a surprising number of mid-Eastern rug shops. You wouldn't think there could be that many floors around.

The Mercedes chugs in and out between a Rolls Royce and a silver Jaguar. The men and women who drive them are dressed in silk and suede and linen and diamonds, a flow that begins to ease Carla's anxiety. The metal of the automobiles combines with the high frequency of the refined metal jewelry to create a rich vibrational pattern, a familiar symphony that today's difficult water belies. But Carla needs to background this thought of the water; her car, as if by instinct, swings into the circular drive around Newport Center, huge science fiction megalopolis with its view of the festively striped sailboats that line the harbor. The car beelines for the second cluster of oak and glass offices, lumbers into its daily slot. And Carla climbs out of the car, running her hands down the sides of her linen layers to straighten out the crinkles, an effort which is inevitably unsuccessful. Linen has become washable and soft instead of crisp and ironed, and yet it remains linen.

She climbs the outdoor stairway with its arty handrails and terracotta pots filled with pink and red geraniums. Then she pushes open the handmade stained glass door of Newport Harbor Fine Jewelry Consulting and discovers that Mr. Powell is standing only six feet away, apparently waiting in front of Alice's chrome desk; his small sensitive hands are clasped behind his back, his huge orange mustache glints in the fluorescent light. They are all so incongruous here, personal styles and tastes strangely skewed, and yet, strangely, complementary.

"Sweet, I'm glad you're here. There's a bit of an emergency," he says, orange eyebrows lifted in slight irony. His left hand rotates front and flexes, a warm-up ritual. "Mrs. Renslop rang at eight. She's waiting in your office."

Carla sighs, knowing she is being ungracious. "Okay."

His eyebrows sag in reproach. "If you had a telephone—"

"Mr. Powell!"

"Not a cell, of course. Just one of those plug-in—"

"Please!"

They both laugh in frustration. Mr. Powell extends his hands toward the ceiling in the universal gesture of resignation, and Carla composes her pale, slightly pointed face into a calm and professional mask.

"Alice went out for pastries from the French bakery," he calls out consolingly as she opens the wooden door to her office, smiling.

Mrs. Renslop is sitting perfectly still, facing the wooden desk, as though she is expecting Carla to materialize in front of her, suddenly switch on like a television set. She is so still that she could be furniture, except that she is wearing a gold watch, excellent quality, and diamond earrings set in slightly inferior gold. Unless someone is wearing it, there is no metal at all in the office. The walls are lightly padded in ice-blue silk to stimulate the intuitive chakra, and also to cover the nailheads and their accompanying vibrations. The desk, three chairs, and an old-fashioned hatrack are all expertly crafted antiques: no nails. The office is further soothed by Carla's collection

of orchids in white ceramic pots. Only the fussy can truly appreciate what it takes to sustain orchids.

The agitation, even through this serene space, of her client is palpable, obvious.

Carla is not acknowledged as she circles her desk and comes into the line of sight. For a moment she stands at attention, wondering if she has somehow been rendered invisible while entering the room. Or, perhaps she has died, and no one has had a chance to inform her yet, those kinds of insecurities.

But Mrs. Renslop springs into life, flinging a large silver necklace onto the desk between them. "Fix it, Carla!" she implores histrionically. "Or destroy it!"

Without buying into the drama, Carla must admit to herself that already she doesn't much like the unpleasant sound of the silver chunking on the wood, and she doesn't like the look of the thing either, its large glinting beads, its serpentine dimensions. Bad business. The water this morning. The volume of the Britannica, brown and yellow map flung open and exposed.

Think about all that later, she reprimands herself, when there's time to make sense of it. For now, just calm down Mrs. Renslop and find a way to appease her.

The two women regard each other. The client appears to be tired although she is, of course, immaculately groomed. Today she is wearing expensive, faux-yoga clothes, embroidered pants of some expensive fabric that requires dry-cleaning; Carla can detect the faint odor of the fumes from the fluid. Her spritely, regal face is complicated with sad lines, a photographic reversal of the expensive streaks in her hair.

Carla slowly bends her knees, carefully easing her linen layers onto the smooth seat of the Shaker rocker. "Didn't we decide you should avoid silver after that business with your grandmother's brooch?" She keeps her voice pleasantly neutral, as if not wanting to spook a thoroughbred.

Relaxing into her chair, finally, Mrs. Renslop shrugs, releasing all responsibility. "One of the boys brought it back from Arizona last week. A steal, really."

"Arizona?"

"Some holy canyon or something. He didn't really go into any detail." Her tone edges into the reproachful.

"I see." For a moment, an uninvited image of an Indian woman hovers on the fringe of Carla's consciousness, a purple velvet skirt and a long dark braid. But Carla has no time for this now; she must concentrate and look hard at this necklace from which her eyes automatically slide away.

The thick, crudely fashioned silver is substantial, heavy, replete with personality. The carving in the silver is both primitive and graceful. Large round beads alternate, seemingly at random, with square ones. The shapes are

irregular and the sizes vary widely, and yet the careless effect is possibly deliberate.

"Let's get serious, dear. Take off your gloves."

While the gloves are being removed, a ritual prolonged by reluctance, Alice enters bearing a platter heaped with delicacies.

"Try the raspberry," she suggests. Her hair is every bit as orange as her uncle's, and the electric blue of the sleek sheath over her ridiculously thin body heightens the citrus tint.

"Are you joining us?" Carla sneaks a furtive glance at the soft bulge of her own belly.

Alice shakes her head, thin lips forming a lizard smile, a cheerful lizard. "No white sugar this week. Then next week—"

Mrs. Renslop pointedly clears her throat and Alice departs. The almond allure of the icing and the smell of fruit jams permeate the office. Carla's stomach growls faintly.

"I have my reiki in forty minutes, dear."

Carla pours two cups of French roast and pushes the black one across the desk. Mrs. Renslop is always game for caffeine. She loads her own cup with thick cream from the wooden icebox, which Alice kindly keeps filled, and two heaping spoons of brown sugar. No point in depriving oneself of life's measly pleasures, especially under stress. She takes a teasing bite from an apricot confection and then, resigned, she forces her gaze, mulishly slow, toward the necklace.

Brackish as this morning's water, it squats there, an inscrutable taunt.

The clasp is often the safest place to begin, but is there one? She leans down and the odor is sudden, pungent, moldy pennies and mounting fear and an astringent scent—poison? Gun powder? Her head bobs back up like an apple.

No clasp.

The existence of a clasp is a small clue to the crafter's psyche. If the circle can be undone, the energy can be disconnected, like a cheap set of Christmas lights.

But the crafter of this necklace is not concerned with this precaution. Oh no. The maker of this necklace...

"My reiki appointment."

Steeling herself (or should the expression be "platinuming herself"?), Carla points her left index finger, tentatively creeping it toward a large, squarish shape, perhaps the largest on the necklace.

"Yeow!" Her hand snaps back instantly, the head of a suspicious turtle with lightning reflexes. The instant of contact was so intense that Carla holds the image like a flash photo: a jolt somewhere between what the doorknob gives you when you've been scuffling across the carpet on a dry summer day and the twitch your body makes, false falling, when your muscles are tired,

and you lie down, and you just begin to relax, to drift away…

"I told you so," Mrs. Renslop intones, placing a juicy blueberry croissant on a lacy napkin and handing it over. "You think I'd be here so early for nothing?"

Carla lets the question remain suspended in rhetoric, comforts herself by fiddling with her gloves. She massages the buttery leather, rearranges the artificial hands so they are thumb to thumb, comforting each other. A sympathetic pair, medieval soulmates.

"It was all I could do to bring this over today, and I'm not a professional."

Carla sighs. Last week Mrs. Renslop had a tragedy with some sapphire earrings. Three weeks ago, it was the pewter locket. Still, somehow this necklace feels like a genuine problem. Something to which she is not accustomed. Frankly, she has no idea exactly how to handle the situation. Besides, the coffee is undrinkable; Alice has used the Revereware kettle again, with the copper bottom.

"I know you think I'm hysterical," Mrs. Renslop is saying, "but I'm not. After all, you are the one who is always cautioning me to be careful!"

"How long, exactly, have you had this?"

"Why, Mark just brought it home last Tuesday night! And then, uh," her face begins to acquire an expression of cunning, the downward lines of her eyes and mouth stretching horizontally. "There was the opening at the museum. One of those fabulous installations, something about the plight of some tribe or other, I forget which one, but it was very worthy, very illuminating. And the reception was simply to die for! Miniature corn—"

Carla raises her palm for silence. "You wore this necklace to the opening?" She tries to keep the surprise, and the disapproval, out of her voice.

"But I had this fabulous new Donna Karan, very Zen lines, in the loveliest shade of blue. It simply shrieked for silver, and nothing delicate did it justice."

"Oh." Carla is aware of feeling embarrassed now, forcing out all this self-justification and personal information. She is a counselor, after all, not a parole officer.

"And I only kept it on an hour, just enough to make my entrance. You see, I knew it was affecting me. You've taught me so well what to watch for."

This attempt at appeasing and pleasing is transparent, and yet it works. Carla feels pleased and somewhat mollified. There are solid rules to her system, and they are good and necessary. Daubing jam from her lips and fingers, she resolves to tackle the necklace once again. This time she has a rough idea what to expect; the shock will not be a stranger, the awful surprise, answering the doorbell when you're not expecting company.

"I'm going to lean against the wall," she explains, prying herself up

from the chair and walking around to the side of the desk. Placing her heels about six inches from the wall's padded surface, she presses her shoulders back into the soft comfort, leans back into a vertical bed. "Could you hand me the necklace, please?"

"Oh, I get it!" Mrs. Renslop picks the thing up with her bare hands and doesn't even flinch. "You're grounding yourself." Then she laughs gaily, extending your hand. "Actually, you're *walling* yourself!"

Carla smiles politely and reaches for the necklace.

This time is not so bad. More control, less attempt to sympathize. Knowing the approximate texture of the power's thrust, she is somewhat protected. So the shock is muffled, ineffectual, a little frustrated—angry children having a pillow fight, a rubber crowbar.

So you wait a moment.

Something else will appear.

The change is sneaky, the intrusion of a faint odor from another house, but you are cooking your own meal, and the smells in front of you demand your full attention. No doubt you only imagine someone is baking mincemeat pie since that would go so nicely with your turkey.

But this other scent is redolent and poignant. An old gardenia corsage discovered in an obsolete dictionary.

The sweetness is in the fingers now: where the silver touches, a bowl of sugar water. Yet there's also the transformation to solidity; the syrup crystallizes. Or there's a rock in the pillowcase. The pie is poisoned.

"That's enough," Carla tells Mrs. Renslop, who takes the necklace away from her and returns it to the desk. "I guess you'd better leave this with me for a few days."

II

While Carla waits for Lucy to show up, she sits by the living room candelabra and trims her split ends. This is a better nervous habit than smoking, which she gave up last year, but not as good as crocheting an afghan. Her mother believes that any kind of public body attention, even combing your hair, is socially offensive. Scrutinizing the ends of one's hair does not convey the same amount of vulgarity as, say, paring the toenails, but there's still that degree of monkeylike grooming behavior.

Except that this is her house and her mother is in Spain.

Carla's eyes begin to cross under the strain of the close work. She glances up, deliberately ignoring the box, which rests on the glass coffee table. Even the underwater harmonies of the blue and green color scheme in her living room cannot soften the insidious energy of the necklace. All day, in spite of her apprehension, she has longed to return to it: the exotic taste craved, demanded, by the jaded appetite. Like that of all connoisseurs, her profession demands a sort of self-destructive, eliminating quest, an ongoing understanding to be perpetually unsatisfied.

Return to the split ends. She grabs a clump of hair from behind her left ear and holds the tail up to the flickering light. The hair is very blond, so only one precise angle will reveal the tiny deviations. They're almost lovely: tiny frays like miniature palm fronds. Pale and delicate and disruptive.

Snip snip.

These scissors are special, one of the sanctioned talismans. She's had them since the age of seven, and they're very trustworthy. Sewing scissors, shaped like some sort of animal, the tiny jaws opening and closing as the blades. Iron with a little gold and silver inlay. Her mother bought them for her at an antique show, and even the dealer was unsure what the creature was intended to be. A weasel? A meercat? A chinchilla? Instinctively, Carla's hand had reached out for the glittering figure imprisoned under the display glass, and that same comforting contact has remained embedded in the scissors: a gypsy violin in the ballroom, fire crackling in the fireplace. Tomato soup with garlic croutons.

She sighs. How lovely it would be to cut off the entire hank of hair. Her hand aches with the desire to do something so perfect and so final.

Why is Lucy never on time?

The scissors clank down on the rosewood table. Carla stands up and rolls her neck back and forth. No more snipping tonight.

Instead, she takes a paper bag from the stack by the door, lights a taper, and steps outside. The air is cool even for June, heavy with the foggy proximity of the sea. The sweet alyssum also smells of mildew. She plugs the end of the candle into the thick, damp soil of the tiny flowerbed; its vibrating

arc projects giant flower shapes onto the sidewalk. Tucking her hair behind her ears, she squats down and begins to search.

Two medium-sized snails are mating on the dahlias. Their glistening feelers grope ineffectually against the petal backdrop. Plunk into the paper bag. Three slugs are wrapped around the leaves of the prize apricot pansy, miniature boa constrictors. But slugs aren't as nasty to the touch as, say, the average pie tin. Toss into the bag. Another large snail is fumbling his way toward the lavender chrysanthemum.

"You're going to make such a great old lady," Lucy says, standing behind Carla. "Christ, what a retentive thing to do."

"Oh, good." Carla straightens up and brushes off the knees of her drawstring pants. "A new record for lateness."

Lucy follows Carla inside and flops down on the soft blue couch. "What exactly do you do with a bag of snails?" she asks. Although casually dressed in sweatshirt and army fatigues, she is impeccably made-up. In repose, her large features are as beautiful as those of a movie star. But her face is almost never in repose.

"Put them in the garbage bag," Carla says and does so.

When she comes back inside, Lucy has slumped down farther into the couch, as if deflating from the stomach. "Let's see the famous necklace," she says. "I still have a million papers to grade tonight."

Carla inclines her head toward the coffee table. "There it is. Have a look."

Lucy picks up the case and releases the catch. The necklace is shocking against the black satin, silver beads twinkling evilly. Perhaps it is even larger and fatter than it was this morning.

She picks the necklace up with her fingers and holds it aloft, like a snake handler displaying a serpent. Curiously, the beads resemble the tail of a rattler. It twirls slowly and deliberately in the sputtering candlelight.

"I don't think it's Navajo," she announces after a long moment. "I've never seen anything quite like it before. It's truly beautiful."

"Beautiful?"

"I guess you don't think so. Too strange for beauty?"

But Carla will not be sucked into their classic debate. She merely shrugs her shoulders.

Lucy places the glinting necklace back in the case without closing the lid. Her gaze in Carla's direction is unwavering: the forehead wrinkles in a series of regular furrows, like the squiggly lines card in an ESP deck. "So what's the problem exactly?" Her eyes are huge and green, almost threatening.

"I wish I could say." Carla shifts her weight back and forth from her heels to her toes, an agitated hobbyhorse. The object itself is unnerving, yet the dislocation it inspires is not entirely unpleasant. Something tugs at her— what? She cannot remember. Perhaps she has never known.

"Try," says Lucy. "I hate to see you looking so weasely."

With her long, slender nose and slightly close-set eyes, Carla sometimes resembles a sort of platinum ferret. From a distance, her features appear regular and conventional, but, upon closer inspection, her face has a strangely feral quality, which rescues it from mere prettiness.

And now she shakes her head and walks away from the table, gazing at the swirling blues and greens of the walls. She has painted them herself, the enclosing sea of the dreamer. By the side window there is a small German woodblock print of a cheerful alchemist; he doesn't know yet that what he is doing is wrong, that the flames of hell may catch up with him.

"Come on, let's hear it." Lucy glances meaningfully at her brass military wristwatch, a vulgar piece of metal. After two or three minutes of silence she sighs. "Be stubborn. Be mysterious. But at least tell me where it came from."

Carla knows she is being difficult with one of the few people who doesn't deserve it. "Mrs. Renslop's son claims he found it near Chinle, Arizona. Near some sort of canyon."

Lucy's furrows deepen. "Must be Canyon de Chelly. Wonder what he means by 'found?'"

The silence extends again until Carla's manners surface. "I'm sorry, do you want something to drink?"

"How about a can of beer?"

This is one of their oldest jokes. Even nicely bottled wine must be decanted for days before Carla can enjoy drinking it. Knowing her friend seldom says no to a nice Pouilly-Fuisse, she enters the kitchen, opens the wooden icebox, and pours two glasses, a chunky one and an elegant flute.

When she returns to the living room, Lucy has the necklace draped over one knee, as if it has shed its skin. Her mobile face is squiggled with concentration.

When she takes the flute, you can see that her hand is stained with ink. "I think the kid stole this."

Carla nods. The wine rolls like a sweet pearl at the back of her throat. She sits cross-legged in front of the coffee table. "And that's only the first thing wrong."

A few thoughtful minutes pass. They both stare at the necklace and sip their wine, hoping perhaps for some ghostly apparition, that the necklace will speak, that an Indian genie will issue forth in a stream of smoke.

"I've always wanted to go there," Lucy says finally.

"Where?" The other side of the grave?

"Canyon de Chelly."

"I've never even heard of it before. Silly name anyway, house canyon."

"Not *chez*. It's just pronounced that way. It's spelled C-H-E-L-L-Y."

"Oh."

"It's supposed to be some sort of holy retreat for the Navajos, who stole it from the Hopis, who either are or aren't descended from the Anasazi, the ancient race of pueblo dwellers—"

Carla stifles a yawn. Although she is trying to pay attention, boredom is creeping in; one of her worst failings is categorizing things in her mind and then losing interest. As soon as she detected that Lucy was talking "Anthropology," she felt her interest float away, an untethered balloon.

"You'd like it, Carla." Her friend's voice is unusually earnest, as though it is suddenly very important to her that this be so.

Carla wrinkles her nose, and then she does really resemble an albino ferret, albeit an attractive one. "CAMPING?" She suggests incredulously. "Sharing plumbing and water with total strangers?" And she is also thinking of those horrible tin mess kits she was forced to use as a child, before anyone realized how different she was. Pocket knives. Little stoves made out of giant cans—the entire territory of "camping memories" is an emotional minefield of extreme discomfort.

Lucy opens her backpack and, careful to use matches instead of the offensive Zippo, lights her extracted cigarette. "Weren't you some kind of Girl Scout?"

Carla shudders. "Exactly the problem. The only thing I enjoyed was tying knots."

"Okay, never mind all that." Lucy picks the silvery snake off her knee. "Let's get back to the necklace in hand, pun intended."

Even at a distance of three feet, the energy has remained palpable.

And the odor is there when you look for it: sweet, moldy, bitter, poisonous. Oddly, however, it does not seem to emit as much anger as it did this morning. Perhaps Lucy has a positive effect, or maybe the dubious effect of Mrs. Renslop & Son is wearing off.

Carla's hand reaches out, but then stops, automatically, just short of making contact.

"Maybe it's okay to touch as long as I'm holding on?"

Carla shrugs and shakes her head. Who knows? One of the worst problems in being so different is that you must always learn everything by trial and error. Very painful error.

"Or maybe if you touched my other hand, you could sort of sense it through me?"

"You want to be my buffer?"

Lucy leans forward, dangling the necklace closer. "I'm tough. Maybe I'd be good at it."

"What this business requires is *sensitivity*." Nevertheless, the plan is interesting.

They sit side by side on the couch, sunk in the velvet cushions, pro-

tected as a pair of earrings in a jewelry case.

Lucy holds the necklace at arm's length away from them, and then dramatically extends her other palm toward her friend. "O Great Indian Spirit who watches over this necklace," she intones. "O Wise and Ancient One..."

"Stop that!" Carla orders. "This is hard enough." Her cheeks are suddenly burning, and with surprise she realizes she's embarrassed, as if she had been caught gossiping. And you have to let that thought go. Breathe deeply, compose yourself, and think about something clear as water, blank as the surface of a still, mountain lake, blue and deep as the sky. Then she places her palm in Lucy's.

No jolt, and yet the circuit is obviously connected. The heat begins to rise, and it is severe, and then it goes away almost immediately. The essence of Lucy is evident and shapeless: tone deaf and trying to hum a familiar melody. There and not-there.

And then something else begins. This is a surge of pure sweetness, the welling up of some poignant other. A slash of azure. A wedge of pinky brown. Vivid. Burning. Ineffable.

"Why did you let go?" Lucy asks after a moment.

Carla begins to pace. A small Bavarian vase seems to jump into her hands, the mock seventeenth century shepherd and shepherdess make calf eyes at each other, but the gold leaf is tranquilizing. After circling the small living room two or three times, she exits through the kitchen and out the back door. The tiny patio is filled with Mexican clay pots, which are filled with flowers. Reflexively, she begins to poke among the lobelia and Icelandic poppies. Why snails are willing to scale an eight-foot redwood fence only to chomp on her flowers, when there are plenty of flowers on the other side, is mysterious. And why do they favor potted flowers, and certain flowers over other ones? Can snails actually taste? Do they have opinions? Does she care?

When Carla re-enters the living room, Lucy is struggling to light her pipe. Taking the stem out of her mouth, she contemplates the bowl as if reading tea leaves. "Well?" she asks, continuing to stare down.

"No snails on the patio."

"That certainly is good news." When she looks up, her large green eyes are kind.

"You getting the hang of that pipe yet?"

Lucy smiles, making her whole face shift like soft earth in a surprise rain storm. "Not really. Brian says I should alternate a stick with a bowl. I don't want to hurt his feelings."

Brian gave Lucy a half-size pipe, a diminutive version of his own. This was supposed to give her a George Sand image in the faculty lounge. And help her kick her cigarette habit. Of course, now she smokes the same amount of cigarettes and struggles with the pipe besides.

"How is Brian anyway?" Carla resumes her cross-legged position on

the floor and retrieves her glass. The wine, slighter warmer, is more piquant.

Lucy holds the pipe away from her mouth in order to provide an unobstructed view of her facial cataclysm. All the smile lines begin to fade until the face is utterly smooth, ominously model-perfect. And then the disappointment lines set in. She'd be terrific as one of those stand-up comics who turns his back to the audience to change into different personas. "I'll give you five more minutes to get real. Or I'm going to go grade my papers."

Carla cradles her head in her hands. The carpet is as calm in the dim candlelight as a tranquil sea. Why can't she feel that calm? The answer lurks in the box, beads glimmering against the dark satin. The box sits discordantly between a painted wooden otter and a vase filled with pink gladiolas. "Could you please humor me and put that thing in the kitchen?" she asks. "On the counter?"

"Afraid to talk while it's listening?" But Lucy stands up, snaps the lid of the box firmly shut, and takes it into the next room.

Immediately Carla feels more relaxed, as if a window of fresh air had been opened. Her thoughts focus, clear, and shape themselves. The difference between trying to swim with all of your clothes on and the ease of swimming naked. "I'm sorry to be so difficult," she tells the returning Lucy. "But that thing has a bad effect on me. It seems so determined. I can't seem to shake the conviction that it was sent to me because I'm supposed to do something with it."

"Like take it back."

Carla nods her head miserably.

"Got a map of Arizona?"

When Carla goes to the bookshelf, she is not really surprised to see that the volume of the Britannica which is lying open is on the right page. No point mentioning this "coincidence" to Lucy, who will suspect a prank. And it is a prank, but who is the trickster?

Quietly she hands over the book.

After a moment of scrutiny, Lucy declares, "Canyon de Chelly!" Her finger taps the Northeast corner of the state, the dead center of Navajo Nation. "Looks like about eight hundred miles away."

"How long do you think it will take us?"

"What about Michael?"

That's a good question. In the first place, he's in Chicago this week. And in the second place, well, she just never considered him. "You did just say you've always wanted to go there."

Lucy stares straight ahead, addressing the thin air. "I knew this was going to happen. Why bother to be surprised?"

"You've been to Arizona before. I wouldn't know what to do."

"It isn't Mars, for Pete's sake!"

Carla contemplates the long drive in the metal car, even one as com-

fortable and old and relatively secure as the Mercedes. The public restrooms. Touching the taps, and the water. Strange silverware in restaurants. Yet the alternative—not going—is no longer possible; she must relieve herself of the burden of the necklace, or—or what? The hair on her spine rises lightly, tickling; she knows but she doesn't know.

A gust of smoke issues forth from her friend. "God knows, I could use a break from Brian."

"Can you leave tomorrow night?"

III

Impossible to sleep.

Eyes closed, great luminous bats circle out of nowhere, bearing messages of despair.

Eyes open, no bats (naturally) but the room is too calm and pale in the moonlight, as if it is merely a set awaiting the entrance of—what?

Bats?

Carla lies in her pale green bedroom and feels sorry for herself. No doubt it is already past midnight, already too late for requisite nine hours. Peace of mind is unattainable. Sleep lost can never be recovered; it goes into the black hole of unrealized opportunity.

Tomorrow will be a bad day. Fatigue always exacerbates her hypersensitivity, and so she will have to wear double gloves for most of the day. By early afternoon, the migraine will have set in. She'll have to cancel clients, leave the office, too sick to pack, and here she'll be, lying in this same bed again in twelve hours, exhausted before the trip has even begun.

Great.

Maybe she should pack now, get it over with?

She relights the bedside candelabra. The orchids seem to sway in the flickering light, charming but eerie shadows on the walls, an encoded dance, a message that cannot be deciphered.

Sometimes she thinks she should actually get a telephone again, for moments such as these: she could call Lucy, or Michael in Chicago, or even Mother in Spain. Except that her experience with telephones has been dreadful—the sucked energy, the humming connection that is never truly severed: worse than electricity, all things considered.

And, besides, no conversation will solve her problem. Her problem is sitting in its box out in the kitchen, and it is spoiling her sleep. Eyes closed.

A waft of ocean breeze puffs the curtains.

Perhaps she should take a comforting seaside walk? In this community, the night is not dangerous, not even for women. It is one of the reasons she hides here, with her rattletrap (but once expensive) car and her almost (until you look closely) California Girl features. The fresh air will be soothing and soporific. The world will return to its quiet order with the great sweet harmony of the sea.

She doesn't have the energy to pack right now. And sitting up worrying all night will cause premature wrinkling.

As soon as she thinks about wrinkles, she is up and dressing. Jeans, sweatshirt, running shoes. Once she and Lucy were combing their hair in the ladies room at Neiman-Marcus when an older woman approached Lucy and told her that she should learn to control her face. "If you keep showing all

your emotions like that," the impeccably groomed creature had said, "you'll be a prune before you're forty." Her own face had been moist, nearly crease-less, attractive in the abstract and yet repellently humanoid. Lucy had been in a snit the rest of the afternoon. "People with perfectly good skin die in car accidents every day!" she had pronounced, incredulous that anyone could proselytize in favor of bland facial expressions.

Carla had agreed, indignant on her friend's behalf. And yet she had somehow taken the woman's advice to heart.

Now she opens the front door and steps out into the night, resisting the urge to take a quick peek for slugs. After all, the flowers usually fend for themselves during these hours. Somehow they will manage. The air is clear and fresh and dew-heavy. A great foggy ring encircles the moon, witchy por-tent of rainfall. More pungent than during daytime, the mixed odors of marigolds, pansies, alyssum, and jasmine cloud the air, as if the blooms were employing the elegant etiquette of well-dressed ladies: saving their richer perfumes for the evening.

All of the houses along the street are dark. The night belongs to Carla.

She strides oceanward, protected. The world is cute and miniature, these beach cottages for the wealthy. Once built strictly for summer use, the same quaint shacks now house the upwardly-mobile year-round, in spite of minute bathrooms and negligible insulation. The residents imagine there is something fairytalelike about their dwellings, or at least Carla does. The alternative is far worse: a cottage is torn down and a great megastructure is erected, every inch of the lot utilized in the huge, opulent, many-floored resi-dence with its vast metallic air-conditioning and heating system, its high-tech kitchen, its abundance of plumbing and circuitry, mineral networks that drain the sleeping bodies of their energy.

Not to mention the bad jewelry.

The ocean is seven blocks away, far enough to resemble a destination. The sound of the sea is louder and more hollow as you approach. The con-crete sidewalk is wet and criss-crossed with shimmering snail tracks. The surf is pounding below.

Carla crosses Seaside Drive, which is lined by stately old mansions seemingly only occupied by people over ninety-five, and even here the new, charmless high-rises are gaining a toehold. She locates her favorite cliffside observation spot, just at the edge of the greenbelt. The view stretches out toward Balboa Island and the Channel: the lights from the Pavilion glimmer merrily on the Peninsula. The ferryboats are all docked for the night.

Mother used to summer in Balboa when she was a girl, dancing each warm night to bands in the Pavilion. During the long afternoons she would swim, play tennis, gossip on the sand with her girlfriends. Her skin was the rich stain of mahogany, back when tans used to be status symbols. They all smoked their cigarettes carelessly then, too.

Sometimes Carla wishes she could just bring that all back, enjoyment without consequences, fun without retribution. Is such irresponsible pleasure even possible anymore?

Sometimes when you look at a place, a special place where you know something special has happened, you wonder if you could somehow rekindle the scene—as though the place itself holds the power, retains the heat of the happening in the same way that water holds the warmth of the sun long into the moonlight.

Closing her eyes, evoking lazy summer afternoons and ice cubes clinking in classes, Carla sees... a giant necklace, silver-blue and shimmering! Eyes open, she sees the blue pagoda of China Cove, the moon reflected on its indigo mansard roof, the perfect setting for a thirties detective story.

Carla blinks. The pagoda disappears and she sees one of those huge, high-rise modern homes.

The pagoda has not been in China Cove for over twenty years, since Carla was a child.

A hollow pounding begins in her stomach, not unlike the surf against the rocks. Something about the density of the air seems to be changing.

The night is perfectly still. No one else is about. And yet... and yet someone seems to be gliding on the grass behind her, footsteps like tentacles.

Turning her head quickly, Carla is sure she sees the shadowy form of a woman.

No one is there.

There is a trace of breath on the back of her neck.

What does the ghost woman want?

The necklace.

The moon glows suddenly brighter.

Across the slope of the greenbelt, the wild cliff cats have begun to emerge. During the day they sleep in shallow caves beneath the rocks and the iceplant. But now they are out in the open, sitting upright, dozens of them, attentive as prairie dogs. They are rounder and stronger than ordinary domestic cats, and their short fur is surprisingly thick.

They watch Carla carefully as she weaves her way back. Usually they scatter when someone approaches. Tonight, for some reason, they refuse to disappear.

IV

"Wake up." Carla pokes Lucy with her right hand while continuing to steer with her left. "Time to stop for breakfast."

Pre-sunrise. The air is clear, lavender, surprisingly cold. The road has been winding through pine trees, and pine trees were not what she'd been expecting in Arizona.

"Where are we?" Lucy asks, raking her fingers through her short, curly hair. "Wow, I had the strangest dream!"

"What was it?"

Lucy readjusts her bandanna. She likes to wear it pirate style, pulled down over her forehead, but with all her brow furrowing, it always creeps up into the hairline. "There they are!" she exclaims suddenly.

"Who? What dream?" Carla is trying to concentrate, but she is very tired. The night has been long, and dark, and her friend has slept through the whole thing. And her Mercedes, not exactly a breeze on the open highway, is really a clunker on this mountain road.

"See those peaks?"

Carla peers under the sun visor, which always droops down, to get a better angle. Two stately mounds rise above the other piney hills, their twin tops glittering magically in the new light. "Yes, I see them. Very pretty."

"That's where the kachinas live."

This doesn't make much sense to Carla, so she ignores it. Perhaps if Lucy recognizes the geography, she will have some notion of where they can stop. The first pink-black streaks of sunset are aligning themselves with the road, as if to paint a path.

"Don't make your ferret face. This is really interesting." Lucy lights a cigarette with the car lighter, which is safe, and Lucy cracks her window. "You can see those peaks from the Hopi Empire, and they are where the kachina spirits are supposed to live, sort of like a double Mt. Olympus."

Happily, at the next bend in the road, a small café appears. Carla hauls the Mercedes into the rustic parking lot, as if she'd planned on this all along. A dozen or so pickup trucks are scattered about haphazardly.

"Oh, good," says Lucy.

But as soon as the car stops, momentum broken for the first time since their late-night departure, Carla begins to feel strange. Yesterday had not been so bad, after all—no migraine, and Mrs. Renslop had been unusually agreeable. Packing had been efficient, even pleasurable, and she had kidded herself that the whole adventure was a much-needed vacation.

And now that energy has suddenly abandoned her. She feels bereft, as if the current of the road no longer runs through her. The sharp smell of pine needles accosts her senses, and the sky is the color of aluminum.

"How did we get off the main road?" Lucy asks. "Are we close to Flagstaff?"

These are all good questions. Carla sits tight.

"I think you need some coffee," Lucy says kindly. "And maybe you better take your heavier gloves."

"I guess I better," Carla agrees.

She slips the wool gloves on over her leather pair, climbs out of the car cautiously. The air is stunningly chill, and the ground closes an odd circuit of fierce energy.

"At least it's cold enough so you won't look like a complete asshole in those gloves," Lucy points out cheerfully as they head for the café.

The restaurant is unpainted shingles with a steeply pitched roof and dark green trim. Stone steps, small-paned windows—the whole thing is depressingly Christmaslike. Perhaps this explains why the smell of pine has discouraged her—it is actually springtime, yet here it seems to be December, and the dissonance is disorienting, something stumbled upon inadvertently, something you may be hoping not to see.

Her friend opens the door to Amelie's Café and they slip inside. The interior is small and warm, cozy. Several men hunker at the counter, and the rest are distributed among the overstuffed red vinyl booths and chrome-edged tables. It looks like a set for a play, right down to the noble Indian portraits that line the walls, price tags neatly visible in the lower left corners.

They slide into the closest empty booth and a pretty middle-aged woman in blue jeans and braids hands over laminated menus and pours their coffee, wishing them a cheerful good morning and promising to be back in a minute. Surreptitiously, Carla wads some paper napkins around her spoon before stirring some cream into her cup. Yet the energy is benign: all she senses is the faintest whiff of desolation.

"Someone seems to think we're pretty cute," Lucy mutters, hunching slightly over the table. Her face is folded into ridges of disdain, with a few creases of amusement.

Glancing up at the counter, Carla is alarmed to see that a couple cowboy types have swiveled around to gawk at them.

And she is forced to realize that they are, indeed, conspicuous. Her outfit is virtually a disguise in Newport Beach: ecru linen trousers, white linen tunic, and white leather sneakers. Of course, this ensemble looks pretty weird with the gloves. And Lucy has dressed for a mountain climber's costume party: brand new many-pocketed shorts, alpine knee socks, down vest, top of the line hiking boots, and so forth. Compared to the worn flannel shirt of the woman who handed them the menus, they look ridiculous.

"Maybe we should go somewhere else?" For obvious reasons, Carla really hates standing out.

Lucy is softly humming "California Girls" while she studies the menu.

"Like you know somewhere else. We're lucky we found this place."

Before Carla can protest that they aren't exactly lost, the woman returns for their order. Lucy asks for eggs over easy, hash browns, and toast and Carla asks for granola with yogurt, fruit, and raw almonds.

The pleasant-faced woman shakes her head regretfully. "No can do, hon. We don't have any of that stuff."

Carla's increasing uneasiness blanks out her mind. What on earth should she order? Obviously, she is expected to offer another possibility. "What is everyone else having?" she asks like a dunderhead.

The woman grins. "A good time," she says winking.

Now Carla's confoundment is complete. Her face grows paler and the solution to the moment recedes like an image in a dream.

"She's been driving all night," Lucy offers eventually. "She'll have scrambled eggs, sliced tomatoes, and whole wheat toast." As soon as they're alone, she leans forward, crinkled forehead of concern visible beneath the bandanna. "Are you okay?"

"I don't know exactly. I just feel really alien here—like I don't belong." Now that they are out, these are the right words. Speedy chills dance up and down the back of her neck and her eyelids ache, as though grit is trapped beneath them.

Lucy stares for a few more beats, and then understanding begins to seep into her features, softening the lines of concern. They have been friends for nearly ten years, since college, but they have never traveled together out of California. "I get it," she says softly. "You don't like to look different because you are different."

The little wince in Carla's heart confirms the truth.

"In all these years," Lucy continues, "I guess I've never seen you out of your native habitat…"

A hard, coppery taste grips Carla's throat.

"Does this explain why you're so determined to marry Michael? I mean, he's a nice guy and all, but—"

Just as Carla begins really to panic about how to answer this question, this difficult and appropriate question, someone approaches the booth, and they both glance up. One of the cowboys looms above. He is probably somewhere in his thirties, lean and leathery, not unattractive. "You gals rising early or bedding late?" he asks pleasantly.

"We're in for an all-day drive," Lucy says.

Carla is surprised that her friend has responded. Her impulse is to ignore him until he goes away. On the other hand, now she is off the hook, at least temporarily, about Michael.

"Where are y'all headed?"

"Canyon de Chelly."

"Sort of on the wrong road, ain't you?"

Carla is ashamed and tunes out the next part of the discussion, during which the cowboy presumably explains to Lucy how to get from here to there. She can't explain why they are on this road, and this accidental detour is a perfect example of why Carla tries never to travel anymore. Her decisions are based on impulse and not on logical directions.

When she tunes back into the conversation, the cowboy is trying to persuade Lucy to stick around until tonight. Apparently, there is a dance or a hoe-down, or whatever these people have. Blessedly, their eggs arrive after Lucy flirtatiously declines, and the cowboy regretfully departs, door jingling with his exit.

"Do you want to stick around?" Carla asks. Her voice sounds bitchy even though she doesn't mean it to.

"Don't be ridiculous."

Munching on their breakfast, they observe a few moments of silence. Unfortunately, the food proves to be tricky: the residue of the cast-iron skillet, the aluminum spatula, the wire intestines of the toaster. Great billows of panic roll like thunderheads through Carla's body, but she attempts to stifle them. What a bore it is to be this way! Knowing that her friend is aware of none of these issues makes her feel even worse, a pathetic encumbrance with interminable, special problems. And this whole trip was entirely at her own instigation. Yet, in her inner heart, she knows she really had no choice; even now, she is aware of the necklace glowing out from the locked trunk of the car. It radiates desire and demand; its fat silver beads have singled her out. And everything is Mrs. Renslop's fault! Without her burden, Carla would be enjoying a regular day, everything padded and safe, sheathed and cocooned and protected.

And her friend happily sits there, eating her breakfast.

"How are your eggs?" Carla asks, wrestling with herself to be cheerful.

"Great!" Lucy says. "Real potatoes."

While Carla struggles for something else pleasant to say, the door to the café jingles open. Perhaps it is Lucy's cowboy returning for another try? But no—this energy is suddenly very strong, and very new. An old man stands framed in the fresh morning light, slowly scanning the dining room. None of the other men pay any attention. Somehow, however—perhaps in the rigidity of their backs—you know they are deliberately ignoring him. Even the flannel-shirted woman is engrossed in sponging the grill with excessive nonchalance.

After a moment, the old man crosses over to their table and positions himself next to Lucy, who is regarding him with friendly curiosity. Carla is aware immediately and viscerally of the ropes of silver, turquoise, coral, onyx, and Mexican jade which depend from his neck. The palms of her hands press into the tabletop for support; with all her heart she hopes that he will not speak.

The Other Canyon

He is swaying oddly, perhaps drunkenly. A dirty blanket is wrapped around his middle like a bulky sash, and another, smaller blanket creates a sort of turban on his head. Beneath the turban his long braids trail down, their tips decorated with peculiarly shaped beads, squarish and irregular, as familiar as magic.

Carla cannot make herself look at his face.

"Hello," says Lucy, kindly.

He continues to stand there, as if he has not heard. And his body odor insinuates itself into the room: unwashed skin, smoke, and then something bitter yet sweet, green almonds, with a heavier odor beneath, animal and rancid. Bear grease? Carla is ashamed of her own thought, surely Indians no longer use bear grease, but the feral odor is there, ominous and compelling. Peculiarly, there is no trace of alcohol. If he is not drunk, then surely he is crazy.

Carla is filled with a wave of revulsion. She wants him and his pulsating jewelry and his disturbing odor to vanish into thin air, and she wants this as badly as she has ever wanted anything.

"I need a ride," he tells Lucy. His voice is low and precise, so clipped as to seem British.

Lucy actually smiles at him. "Carla, do you think we can make room?"

Carla begins to shake her head wildly. Lucy knows that anyone who rides in her car has to be someone whose energy she can tolerate, who will observe her complicated rules and rituals.

Lucy looks surprised and, for a moment, disappointed. "Oh, no," she tells the old man. "I'm so sorry. We have to make lots of stops, and we're probably not headed where you're going anyway. We're actually on the wrong road."

He stares at her for a moment, and then, while Carla studies her gloves, she can feel his head swivel in her direction. "I, too, am headed to Canyon de Chelly," he says. "And I am in no hurry."

Almost immediately he turns on his heel, swaying haphazardly, knocking against the door on his way out.

After he leaves, the ordinary sounds of eating return, the aimless chitchat that Carla realizes was absent during their brief encounter with the old man.

"Don't mind him," the flannel-shirted woman says, slapping their check on the tabletop.

Carla and Lucy do not respond as they take out their money.

Her smile is less friendly. "He's just a drunk old Indian."

V

The sun will be setting soon—exactly how soon, though, is not entirely clear. Here in the vast expanse of the desert, familiar natural laws do not necessarily apply. Perhaps the fiery orb will suddenly disappear, a red ball falling into a hidden basket. Or, it could hover indefinitely on the verge, reluctant.

At any rate, the Mercedes continues to chug along, no lack of diesel fuel in Arizona. They are heading northeast to Chinle, seemingly the closest town to the canyon's entrance. Although Carla and Lucy have not discussed the subject—they have, in fact, spoken very little since breakfast—Carla assumes a tacit agreement that they be settled somewhere before dusk. She has a sort of fear about where you are when the sun goes down, as if you are somehow committed to the spot you are on when daylight last sees you.

Which makes her sigh. This desert is not very pretty. The sky is close and absolute, the infinite empty message that there is a God but He doesn't much care for you, and His silence is endlessly visible, stretching in every direction from forever to forever. The land is brown and rocky and poor. One of Lucy's rare comments today was that she could see why the government was so cheerful about giving this land back to the Navajos. The parched scrub barely sustains the sway-backed horses and skeletal sheep, never mind the people, who live in round adobe houses with lean-tos out front for selling their jewelry: mostly seed and corn necklaces. Carla had been expecting silver jewelry—in fact, she had half been expecting that the problem of the necklace would have somehow solved itself by now—but the land is surprisingly free of metallic vibration. The hills must have been picked clean long ago, mined by greedy prospectors. After all, if there were still rich veins of ore, would the Navajos be allowed their reservation?

"I find it hard to believe there's a canyon close by," Carla says, breaking the silence.

"That's it there," Lucy says, gesturing casually to a low range of rocky rubble to the north.

"How do you know?"

Lucy sighs. She has been irritated all day because that grisly old man is not with them. "If you knew even the slightest thing about geology, you'd know that there can't be a canyon without some kind of displacement."

Everything Lucy has said today makes Carla feel even worse about herself. She's different, she's strange, she's ignorant, and, worst of all, she's cold-hearted.

The necklace throbs as if in agreement from the trunk, the irregular silver beads (just like the ones in his hair), the weird odor (just like his)... the woman in the night, the faceless head, the hurt in the heart, the feel—

The Other Canyon

"Chinle!" Lucy declares.

Carla steers off the main road onto a narrower one and after a half mile or so, a few buildings appear: a gas station, a Jiffy Mart, a KFC, of all silly things. A half-burned trading post.

"So this is the famous Chinle," Lucy says.

"Look," Carla says, "I'm really sorry if you're still—"

"Wait a minute! Stop the car."

They pull up next to an adobe motel. Ten or twelve disconnected cabins form a semi-circle that opens out onto a broad patch of reddish dust, bereft even of cacti. An old pickup is parked outside the cabin marked Office.

"Are we staying here?"

"Go back to that burned-up trading post."

Carla circles the car back onto the road. Two trucks appear out of nowhere and head in the opposite direction, their beds full of women and children who stare distrustfully past them, dark eyes filled with suspicion.

Just then the sun decides to set, and Lucy and Carla pull up in front of the trading post as the last flicker of daylight fades.

The outside of the building is still fairly intact; you can see that it was once square and modern, big slabs of glass, but the inside has been gutted by the fire. A crude sign in the one remaining window announces OUT OF BUSINESS. And somehow the incongruously functional, high-tech style makes the abandonment all the more forlorn.

"What do you think?" Lucy asks. Lightly, she pats Carla's shoulder. "And I'm not mad at you. It isn't really your fault."

Carla is not quite mollified by this remark, but she is too tired to debate the point. Gingerly, she opens the car door. The air is surprisingly cold. "Ouch!" she yells when her feet touch the ground. "Shit!"

"What's wrong?" Lucy is already out and standing next to the burned-out building. Her silhouette hovers transparently in the pale dark.

"The ground feels *very* strange." But she is determined not to be a wimp and plants her tennis shoes on the ground again. This time the energy is not as bad, but ugh.

The message is very clear: GET LOST.

"What's wrong with the ground?"

Picking her way over to her friend, Carla tries to think how to explain the sensation more precisely. This is the true curse of experiencing those things which cannot be measured, the curse of the sensitives who can never finally distinguish between where the imagination lays off (if it ever actually does lay off) and where the actual begins.

Provided, of course, that there is an actual "actual."

Carla settles for, "It isn't very friendly."

They both stare in the direction of the building, but the night has become so dark already, like an influx of inky air, that not much is rendered

visible. What must be a coyote, or perhaps a wolf, howls in the distance. The ground shudders slightly, but that doesn't seem very likely, does it?

"How about if we just turn around and drive until we find a Holiday Inn?"

Lucy laughs. "And what about your necklace?"

"On our way out of town, we swing by the canyon and throw it in!"

"Not very likely." Lucy lights a cigarette. She seems to have abandoned any pretense of the pipe. "We're here, and we're going to do this thing right. We're taking the tour in the morning, the whole bit. I've always wanted to come here, and now I'm here. Maybe this is my only chance."

Meanwhile, the ground keeps trying to tell Carla something. Perhaps they are near a copper mine or an underground river, loaded with metallic effluvia, the mysterious minerals of the hostile desert. Uranium?

Or, then again, not so unpleasant to contemplate, maybe it is the radical difference in soil composition which is disturbing her, simply because she has never experienced it before—like a compass in outer space. Maybe her body only works properly in California.

"Why did you want to stop here?" she asks.

"I don't know." Lucy's voice is thoughtful.

"Well, can we go now?"

No denying how unpleasant the feel of the ground continues to be. More than ever Carla is aware of her alien status in this place, her inability to accommodate. And even if she should be capable of adapting, she is already rejected. In Newport Beach, there is mutual regard between her and the sandy soil.

"Stop feeling sorry for yourself for five minutes, why don't you?" Lucy's voice is preoccupied, and her footsteps in the gravel describe a journey around to the back of the trading post.

Now Carla feels completely isolated. And every minute the temperature seems to drop another five degrees. So, then, of course, you always feel watched in these situations, always imagine that in the moment of abandonment, unfriendly eyes are observing you.

"Aren't you hungry?" she shouts, hoping her voice carries around back. "Don't you want a drink?"

Perfect silence.

"Hey! Remember me? It's getting cold! Let's go!"

What might or might not be a wolf howls again, perhaps a little closer. Rubbing her arms up and down, and hopping a little, Carla tries to take long, deep breaths. "Food! Food now!"

Nothing more perfect than perfect silence. "LUCY!!!"

"COME HERE!" she shouts back. "I'VE FOUND SOMETHING REALLY INTERESTING!"

Carla scurries blindly around the corner of the burned-out shell to find

The Other Canyon

Lucy crouched over some boxes beside a rusting dumpster, pale light flickering from the ever-offensive Zippo. "Why are you poking through this junk?" she asks. "This is trespassing."

Lucy straightens up and brushes off her knees. "This place has only been out of business a couple weeks."

"That's really fascinating, all right. Now let's go eat."

Reluctantly, her friend follows her lead back to the car. "Well, it *is* interesting. This trading post has been around since the thirties. There was an older building here originally, but even this one's eleven years old."

"How do you know?"

"I use my head and pay attention."

"Good for you, Holmes. You can give me the detail work over a nice, hot meal." The relief of being grounded in the Mercedes, rattletrap that it is, is as effective as a massage. The familiar vibrations allow her to relax, don't worry, everything will be taken care of. We will do the work, and there will be no surprises. Shutting the door against the cold, she begins the elaborate procedure of starting the diesel. Comforting. "Sorry to be such a bitch again. But it's cold and dark out there. And weird."

"Weird, indeed," says Lucy. "In fact, there's something weird about this whole town."

From the bowels of the trunk, Carla senses the necklace, as if it is growing stronger, reconnecting with the Mother Ship. "'Town' is generous. I hope we don't have to eat at KFC."

They drive in what a single sign indicates is the direction of the campground, past what might be stores that are not easily identified. And a few actual houses. There are lots of pickup trucks around but no visible people.

Just when it seems that they will have to circle around and sup on fried chicken, they spot a large cluster of trucks parked in front of a long, low building with a mural on the side. A sign announces: JOSE'S MEXICAN CAFETERIA.

At the same moment that they pull into the lot, the red double doors open and four people emerge, framed in the light of the doorway: three men and a woman. The man who attracts Carla's attention is dressed entirely in black except for his mirrored sunglasses. His dark, shoulder length hair hangs in wily snakes around his large, pale face. The other three are also dressed in dark colors, their slender bodies slouching in the cool evening as they puff away on their smokes.

"European hippies," says Lucy.

"Why do you say that?"

"I can just tell." Her friend's voice is unusually contemptuous, and as they pass in front of the car, a jabber of German and French is audible.

The man with the long, curly hair is somehow familiar. And how can that be? She has never seen anyone else who looks like him, with the possible

exception of photographs of Jim Morrison.

"Not exactly your usual type."

Carla remains at the wheel, adjusting her gloves. Things just keep getting stranger and stranger, as if some new and decidedly unpleasant dimension has been added to her life. The very quality of the air is changing, irreversibly, and not for the better. On the other hand, they've been on the road for about twenty hours—lack of sleep will always make the world go odd on you, but that isn't exactly the problem. Nor is the problem exactly her loss of control, her hypersensitivity to powers she cannot predict, or, seemingly, protect herself from.

At the sound of gravel, she glances to her left. The European hippies are tooling away in some sort of huge American car. The man with the snaky hair is at the wheel.

Lucy climbs out and Carla follows, wary of her contact with the soil, but here the vibrations are subtle, muted, and they walk toward the red doors, pausing after a moment to puzzle out the mural. In the very center, against a bright blue background, a circle of five hands pulsates goldenly. To one side of the hands, stick-like human forms dance cross-legged, but their feet are webbed, and their heads, truly peculiar, are whole ducks in silhouette. Some of the other stick forms have star-shaped heads, but their legs are uncrossed, and their torsos are fat and chunky. On the far side of the circle of hands, a lopsided human shape appears to be playing some sort of musical instrument while a flock of stylized wild animals frolic around.

"The hump-backed flute player!" Lucy exclaims.

A wave of despair only partially diluted by irritation washes over Carla. "Now what?"

"He's a kind of fertility symbol. The flute is, obviously, phallic. He's a minor god, and he's been depicted in pottery for thousands of years. More recently he's been designated as the Hopi kachina Kokopelli, sign of the Flute Clan."

This is Anthropology, and yet it is sort of interesting—there's something powerful about this odd, lopsided fellow. "What Flute Clan?"

"The Hopi Flute Clan claims direct blood to the Anasazi, the people who used to live in Canyon de Chelly. The flute was probably what they used in religious ceremonies, the flute and some kind of drum or rattle."

Carla stares. Almost she can hear a far-off strain of the reed instrument, smooth and hypnotic. But then the door spills open, a family exits talking and laughing, and the moment is broken.

Inside, you have to blink to adjust to the bright light. The room is surprisingly large, bigger than it appears from the outside, and the low ceiling combines with the rectangular shape to create the ambiance of an underground parking lot. All available space has been implemented; there are lots of tables, lined up in precise rectangles.

Perhaps thirty of the tables are occupied at the moment, which is still a large crowd, but since so many tables remain empty, there's that sense of dominant vacancy, of ghostliness.

No one pays any attention to the California women. They hover by the door, wondering what the rules are, how you do this thing. As far as you can tell, everyone else is Navajo. Most people are dressed casually in blue jeans and tee shirts, but at one table, at which there seems to be a party going on, the women are dressed quite stunningly: velvet skirts of magenta, forest green, and red rust, with contrasting satin blouses: canary yellow, bubble gum pink. And the bright colors are merely the showcase for the true stars: the jewelry.

Here is the root, the origin, of the ongoing discomfort—an overabundance of silver.

Silver with turquoise, with coral, with onyx, with Mexican jade. Silver with bone. Silver and turquoise and ancient seashells. Silver all on its own, large and heavy and always with the ongoing energy, that unique smell and vibration and texture that spells *silver*.

Carla has often been in rooms filled with wearers of gold and diamonds and platinum: the opera and the ballet. But this kind of silver power... never.

Thick yet shimmery.

Oceanic in its rolling peculiarity.

And nothing at all like The Necklace.

"How about we just go ahead and sit?" Lucy suggests.

Carla's bottom receives the metal chair with a jolt, more sensory input, yet this force is both garish and benign: stale popcorn, crying children, hair gel, thick wool socks, kind of like Christmas at Woolworth's. Fortunately, the table is wooden, so she rests her gloved hands, reeling slightly from all the bombardment.

"Looks pretty good." Lucy is studying the menu, which appears to be mimeographed. "There's stuff here I've never even heard of."

Carla sighs sadly. As tired as she is, and after all that she's been through, all she desires is the normal, the familiar, the safe. Though, to be perfectly honest, the familiar is what she always welcomes. "Is there anything like egg salad or tomatoes and cottage cheese?"

"Sorry."

Between the chair and the jewelry and all the rest of it, Carla's hunger is leaking away like air from a punctured balloon. She feels grubby and unsightly as well, her blonde hair both greasy and dry, her pale pink polish chipped, her face tight with dust, her head throbbing pre-migraine.

It would be nice to eat something simple and leave rapidly. However, the two teenage girls who appear to be the servers are giggling and lurking in the corner with their friends, silver jewelry over rocker tees.

Scanning the room for some hope of relief, Carla meets, or, rather, connects, with the gaze of a disturbing old man in the far corner. The navy intensity of his eyes sends a wave of coldness down her spine, and suddenly she is ashamed. Ashamed of being the ugly outsider, intruding upon and judging people whom she has no right to judge. It is her failure to adapt, to see clearly, which is creating this stress. Hugging her shoulders, she involuntarily drops her eyes from his gaze onto the bottle of hot sauce that forms a trio with the salt and pepper shakers. Raising her eyes again, determined, she sees the old man disappear through the swinging door into the kitchen.

Strangely shaped silver beads hang from the ends of his braids. An old red and black blanket binds the middle of his body.

"Shit."

"Now what's wrong?"

She rakes her fingers through her hair, trying to get it away from the hot surface of her face. Her skin seems to be sweating oil. "I just saw that old guy."

"What old guy?" Lucy's face shifts into wrinkles of inquiry, and she looks surprisingly fresh and clean, make-up and hair perfectly intact.

"The old guy from breakfast. The one I wouldn't give a ride to."

Her friend's face rapidly assumes the upward diagonals of excitement. "Where?"

"He just disappeared into the kitchen."

"Oh. Well, maybe it wasn't even him. All these old men look pretty similar."

Perhaps. But the blanket and the beads? This morning she never really saw his face, never saw that vivid energy in the eyes—or she never would have denied him. His gaze is a gaze that does not brook obfuscation.

"It was definitely the same guy. Don't you think that's kind of strange?"

"Why?" Lucy asks. "Oh good, here comes the waitress. He probably got another ride right after we left. After all, this is where he was heading." She shifts her eyes upward. "Hi! I'd like the posole, some blue tortillas, and pinto beans. And a great, big iced tea."

No doubt his presence is not so strange. His ride was faster, even though they plugged along, seldom stopping. What's so hard to believe, so mysterious? But even as she eats the delicious cheese chile and cheese enchiladas, with fire salsa on the side, she continues to shiver.

VI

Setting up a tent in broad daylight is already Carla's idea of a bad joke, but trying to do anything outdoorsy in the inky night, the air cold and hostile, the wind blowing clammy grit all over you, who knows what howling in the distance... she waits in the car and nurses her migraine while Lucy scans the campsite and checks out the other campers. There are supposed to be forty spaces, most of them just plunk on the bare dirt, partially sheltered by whistling cottonwoods. When they drove in, they saw what the other campers had: Airstream trailers, fancy Holubar dome tents, even those vintage pop-top Volkswagen vans. RV's are not allowed here, which is why Lucy thought that pitching a tent would be so quaint, such a fabulous plan for orienting them to their surroundings.

Ha.

When Carla sees Lucy returning to the car, flashlight scanning the ground before her, she gingerly steps out. Once again the vibration is relatively safe, except there is a strange energy that she detects as "European," perhaps German or French.

They face each other in the cold, gritty night.

"Why don't we just go back and find a motel?"

Lucy wants to be the stalwart one, the intrepid one. She is. There is no competition.

"I'm getting one of my headaches. And there isn't even a bathroom here." Carla makes her voice as naked as possible, so her friend can hear how genuine is this plea. If she doesn't sleep tonight either, well, then, let's just say that would be very bad. The idea of it makes her head throb with real fear.

"This place isn't so bad." They both know that Lucy really doesn't want to camp either, but she has more pride. Her position must be clear: the One Who Would Have. Then, when she relates her adventures to Brian or whomever, her reputation will be intact.

"Please?"

"Well, okay. Since you aren't feeling well. But this might have been a lot of fun."

"I know," Carla soothes, as they both climb back into the car, relieved. "I'm a terrible sport."

"Back to that place we saw in Chinle?"

"I guess," says Carla cheerfully. It couldn't be any worse than this place! Yet, for all her lightness of tone, her relief is very real. Alone in the night with the necklace nearby, what might have happened then? Even thinking about this makes her anxious, heightens the throb in her head.

Somehow she had not imagined the situation would be so serious, so

foreign. The idea of travel is glamorous, and the reality is so final. You are cast out alone.

"Isn't Chinle the other way?" Lucy asks, lighting up. This time she remembers to crack the window.

They are creeping around rutted dirt roads, and a sense of direction has never been Carla's claim to fame. Surely there was only one way back to the main drag, and surely this was it? However, it didn't seem so long when they arrived at the campground.

Just when she is about to turn around, a sign appears out of the dark: SPIDER WOMAN LODGE.

Is this a tourist sight or an actual place to stay?

"Where are we going?"

"Let's check out this lodge," Carla says, surprised that her migraine seems to be abating. It is unusual for her headaches to abort themselves.

They continue to wind around the rutted road for a quarter mile or so, trees dangling over the passageway, and once again they almost turn back, when out of the dark Spider Woman Lodge rises up before them like the original Grand Hotel of the desert. It is an elaborate wooden construction, heavy on the gingerbread, too tall and narrow for its space. Probably Victorian. A smattering of uncomfortable pine trees flank the sides of the structure and the graveled parking lot. There is a separate structure adjacent to the main lodge: a souvenir shop with small paned windows. A theatrical totem pole is decorated garishly, bright as the red trim which festoons both buildings.

Carla shrugs and parks the car. How could one mere necklace have led to all this? You never know the chance decision in life, she decides, which will inevitably direct you down the road you intended never to travel…

The ground is more concentrated with the European vibration. From the trunk of the car, the blue snake presence cries out, a fearful riddle, disconcertingly close to the source of the dark energy. On the other hand, there will probably be mattresses and flushing toilets.

In her heart, and only if she ignore her mind, she knows she has to be here.

"Look there." Her friend points as they head for the office. "That's the same car we saw at the dinner place. The hippies."

Sure enough, a huge maroon Chevrolet, who knows how many years old, is parked capriciously across several slots, but not in the way that expensive car owners protect their cherry vehicles with the old on-the-diagonal-trick. This is the sloppiness of indifference.

"So?" But Carla's stomach does a tiny dance.

"So nothing. You were staring pretty hard at that one guy."

They enter the office while she debates responding. So she was staring—so what? She was tired. Is it a crime to stare? After all, she isn't married to Michael yet.

Whoa! Wait! How did marriage and Michael get into this?

The tiny office resembles a dry cleaner's: all there is is counter. Various ancient brochures for Arizonian points of interest are stacked along the surface, more as barricade than offering.

"Could you ring the bell?" Carla asks. Her double gloves don't seem strong enough against the formidable steelness.

The blank, heavy plong summons a short woman with a long, dark braid. She is wearing blue pajamas, a plaid bathrobe, and plenty of teeth. "We've got lots of room," she announces cheerfully.

Lucy signs them in while the woman stares at Carla, grinning to excess.

What, exactly, does she find so amusing?

"Would you like to take the jeep trip tomorrow morning?"

Lucy's head bobs up. "Can we sign up here?"

Even though she knew this was coming, Carla's heart sinks. Now she thinks of that Japanese poem, which declares, *I always knew that one day I would take this road, but yesterday I did not know it would be today.*

"You get a native guide and a boxed lunch..."

Great.

"Do you have anyone else signed up for tomorrow?"

"Just four. And the jeep holds twelve. You'll have plenty of room. It takes all day. But it's worth it, if you really want to see the Canyon, that is."

Lucy looks at Carla, who looks at the counter. This wasn't exactly the plan. Theoretically, they were going to sleep late, then stroll down to the White House entrance, which is the only way that non-Navajos can enter the canyon unescorted, and ceremonially dispose of the necklace. By mid-evening, they could be lounging in some luxurious hotel in Phoenix, lying by the side of the pool and sipping martinis.

Obviously, things have changed.

"This would give us a chance to see the whole canyon! I mean, it would be much better for you, actually... you'd know exactly where to make your, uh, offering."

"Offering?" asks the Navajo woman. "This is not a religious canyon, you know. You're not supposed to leave anything in there. We don't encourage any worship associated with—"

Carla looks up sharply; the woman's face has become a mask. "How early is this jeep trip?"

Six in the morning is not her favorite hour.

After registering and reassuring their hostess that their behavior will be exemplary tomorrow, they wander over to the gift shop while she sends someone to "freshen" their room. The lodge is undeniably peculiar. There were more than a dozen cars outside besides theirs and the giant Chevy, yet

the space seems barren, the dense air hanging about them like memory.

A kind of tunnel connects the lobby, which is hung with sheets while "repairs" are completed, to the gift shop; they walk down through faint electric light and then up again, emerging inside the store. It is as if you have traveled backwards in time. Thick, tinted plastic covers the dark windows, and the merchandise seems ancient and dusty; what is crammed under the counters is not even really displayed but stacked haphazardly. The majority of the stock is jewelry, that ghastly silver jewelry: silver with turquoise, and silver with coral, or onyx, or Mexican jade. Carla considers having a small sign banning the metal from her office space—would she really lose any necessary clients?

Lucy forges forward to examine the wares, but Carla backs away, almost knocking over a rack of yellowed postcards. Extricating herself, she finds her gaze drifting to a wooden shelf sagging under the weight from dozens of large, intricate kachinas.

"Yes?" asks an enthusiastic voice. The head of an older, white man has popped up from behind the counter where Lucy is standing. Apparently he was working on the floor, or taking a nap.

"What beautiful jewelry!" her friend gushes. "Would it be too much trouble for you to let me try on that ring? That little one there. No, not that one. To your left..."

Carla returns her gaze to the kachina dolls. The faces, although weirdly painted—the half-dog bodies and nasty-looking buffalo horns—have a certain cool dignity, not clowns or buffoons. They stare as if they were seeing something important, something they respected, as if a kind of ceremony were being enacted in the still, transparent air. Not mere costumes, these are serious costumes.

Still, the tiny bit that she knows about pueblo-dwelling peoples has never seemed especially interesting. The idea of living in small, windowless boxes and dancing around with snakes every now and again, as she assumes the Hopis did, has never captured her fancy. And the life of the squaw could hardly have been desirable—unless you got to be an exotic maiden in fringed buckskin, long black braids streaming over your shoulders as you sang haunting love songs on the edge of a leafy glade. More likely, you were grinding the corn all day long, hoeing the squash, waiting hand and foot on the warriors, and trying to keep your squealing children from plunging to their deaths off the edge of the cliff.

And would her life with Michael actually be so different, she wonders, on the metaphorical level?

Once again the kachinas capture her attention. What are they maintaining? Look too closely, and the mystery is evanescent. Obviously, they can't really be gods inhabiting wooden bodies. But they sure aren't dolls, either—dolls who seem lifeless in the daytime and might, in the imagination of chil-

dren, behave differently at night.

No. These kachinas are art: sparks off the fire—art as the image, the illusion, of something greater in the Other World.

Which is also Platonic nonsense.

Carla looks back at her friend, who has several jewelry trays before her, happily trying on one ring after the other, no thought of needing gloves.

"That one," the shopkeeper is saying, his thin blue hair shining like, well, like silver, "is supposed to have some kind of special power. Story goes, a warrior's mother was trying to protect her son. So she makes him this special ring, see. Got some kind of magic in it."

"How do you know that?" Lucy holds her hand out to admire the piece.

The man's face is as characterless as a musk melon. "It was in the dead Indian file."

"He died!" Lucy gasps, as if dying were an extraordinary event.

"No no no no no," the man soothes rapidly, a chipmunk series of clicks. "They run out of money for liquor and stuff—they surely do like their liquor—and so they give me their silver for a little dinero. Sometimes they get it all back, and sometimes they don't. I might make a little money off the deal, but where else are they going to get their hands on some cash in a pinch? Still," he continues, "my prices are more than fair, considering."

Lucy removes the ring. "What is this, some kind of pawn shop?"

His melon face does not flinch. Perhaps he is one of those people too dense to be insulted. "Sort of," he responds, cheerfully.

Even from twenty feet away, Carla can sense her friend's back bristling. With a reluctant farewell glance at the kachinas, she rejoins her friend and links elbows. "It's getting late. I bet our room is ready by now."

She hustles her out the other door, toward the parking lot and their luggage, but not in time to avoid the full thick energy of the pawned silver contracting her gut like a medicine ball. The door jangles closed behind them.

Outside, the cold air is smoke and verbena. There is a kind of ruthless purity to the smell of things, a conviction that what is obscure must, under constant pressure, come clear.

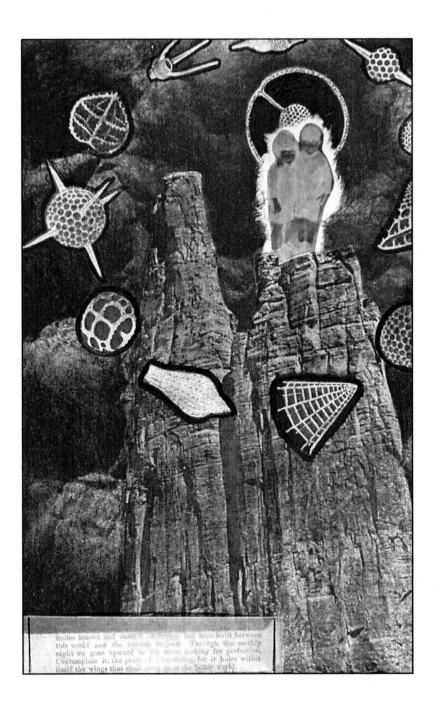

unites heaven and earth, a bridge has been built between this world and the lands beyond. Through the earthly night we gaze upward to the stars looking for perfection. Contemplate it, the pearl of chastening, for it hides within itself the wings that shall carry us to the better world.

VII

"What if I get carsick?" Carla asks. "Or, maybe worse, jeepsick." She is lying reversed on a lumpy twin bed, head dangling over the end, brushing her hair. This, her mother often insisted, was the best way to do it. Blood to the pores. Or whatever.

"Then you do," Lucy agrees. She is standing in the dressing niche, swathing her face with moisturizer. For Carla she is upside down, which severely heightens the sense of ritual.

"You go on the jeep. I can ask someone how to get to the White House ruin. I can go in on my own, without the native guide, and return the you-know-what." But even as she utters these words, she knows she would hate that, would panic. What might that nasty silver do to her down there, all alone?

The static in the brush crackles like a message that is lost in the stratosphere, but keeps trying, nevertheless, to make it back to earth.

"The necklace goes on the jeep." Lucy begins to pat more stuff under her eyes, using her fourth finger like they tell you to do, so the pressure isn't so great. She may refuse to stop expressing her emotions, but she sure knows how to slather up for the night.

"Why?" Idly Carla contemplates the state of her split ends, which have probably tripled in the desert air. Foolishly, she left her scissors back in California.

Lucy turns away from the mirror with an abrupt gesture of finality. "I had a dream while you were driving."

Carla jerks upright and her hair piles into a fluffy haystack. Little red and black dumbbells appear in the air before her eyes, and then they go away. "What kind of dream? Prophetic?"

"How would I know?" Lucy leaves the niche and crosses to the other bed and sits down on the yellow chenille spread, decorated with a brown and red cowboy roping a steer. "You can't know ahead of time whether or not a dream is going to be prophetic."

"Oh, you know what I mean!" Her face is growing warm, and her skin feels hot under the pale green kimono. "Did it feel prophetic?"

Lucy's newly rehydrated face is smooth, a real Zen negation. "Just kidding. There wasn't any dream." She lights a cigarette with Spider Woman matches and places the charred stick in a cheap glass ashtray.

Carla sighs. It is too late, and she is too tired to pursue this. Her friend is in one of her "difficult" moods. Gathering the kimono around her, she walks into the bathroom and shuts the door. Tiles, the old-fashioned kind, cover the walls and floor in turquoise and coral. Or, more accurately, the bottom three-quarters of the walls: the top quarter is like a low, round ceiling,

descending to greet the walls in a friendly manner. If there were a drain in the center of the floor, this room would be a snap to clean.

Carla takes the bath mat, damp from Lucy's shower, and spreads it out to stand on. The room is humming with an odd, heavy energy which makes her somewhat apprehensive about stepping into the tub. The mat is decorated with the name "Kachina Kabins," as are most of the towels. Two are from a Best Western in Albuquerque. Not employing your own towels is generally the sign of a fly-by-night operation, and yet the Lodge gives the impression of having been around for a long time.

Carla snaps open her make-up case with its genuine gold clasps, an unusual indulgence, and savors the cool, self-contained connection. Nothing else feels precisely like real gold. Carefully, she removes her leather gloves and dons her cotton bathing gloves. For turning on the water, she has cleverly brought a thick, kitchen potholder. Shuffling with her feet on the mat, she navigates it tubside. Yet she hesitates: perhaps a shower is too great a risk, considering her level of fatigue? But her skin is so nasty with oil and dust! She would like to step out of her skin, unzip it like a suit of clothing and inhabit a new vessel, one that would soothe her, clarify the vulgar, opaque forces of the world through which she is daily compelled to move.

Surely after this life there will be something less trying?

Brushing aside the yellow shower curtain, her right hand with potholder reaches for the chrome taps. Then, before she can even consciously register the contact, her hand is back and tingling at her side.

What on earth?

Perhaps this is what being hit by lightning feels like: the sense of displacement, the slight interval of time disappeared forever, that split-second never regained, the black hole of gone experience. One minute your hand is reaching out, and the next minute you find yourself sitting on top of the closed toilet.

Carla sighs again.

Then, she raises her left arm and casually sniffs. Yes, a shower is *de rigueur*. After traveling so far for so dubious an errand, she will simply have to face up to the accompanying consequences.

Newly determined, she wraps face towels around her feet and washcloths around her hands, on top of the gloves, and once again approaches the bathtub.

Next thing she knows, she is perched once again upon the toilet.
But at least this time the water is running.

A third, very heartfelt sigh.

When the going gets strange, the strange get going.

What else can you do?

Thinking this may be the death of her, and too filthy to care, Carla pulls back the shower curtain all the way and steps inside. And almost imme-

diately she is aware that she is no longer inside the bathroom at the Spider Woman Lodge—or inside any bathroom in any building. The air is clean and cold and fine. When her hands stretch out, she does not encounter any walls, and yet warm water continues to surround her, a protecting cocoon, an enveloping fetal wall. And then the air is suddenly light, it is dawn, and beyond the water wall she can see endless cliffs, an infinity of cliffs receding into the distance, pink and stiff as ears. The wind is sharp with verbena and wet clay; the water falling around her is rain. Carla is in a strange new place, and the rain is cleansing her, purifying her for entry into a new world, a kind of birth. And, yet, she somehow also knows that if she could summon the will or desire to break free of the water's embrace, once again she would be standing in a tiled bathroom in a lodge in northeast Arizona.

Desire is the key word. Why not remain?

The rain drums on and she adjusts to its rhythms, learns to hear the cries of the wild birds waiting in the sheltering mesquites and hollow cacti. A low underthrob, chant without words or voices, pounds up from beneath the soil.

She looks down at her own body and it is not there—only water.

And only now is she afraid.

A presence startles her. A woman seems to be waiting in back of her, but when she turns her head, no one is there.

And also the figure of a man. His shape is shadowy, but the silver baubles are only too familiar. His face begins to loom up from behind the rain that is falling gently, so gently that it will fall forever. His hands reach up and outward at the veil, the veil which shrouds his true form, and then...

"Yeow!" Carla shrieks. She is standing on the Kachina Kabins bath mat.

"You okay?" Lucy's voice is groggy.

"Fine! Go back to sleep!"

The water is no longer running. The bathroom looks the same as it did when she entered the room. Carla lifts one arm to see if she ever showered and catches the sweet scent of verbena.

Shaking her head, she bundles her hair into a towel and swabs her skin before assuming her kimono. A little moisturizer for the face, a brief session with the toothbrush. When she removes the towel, pale hair falls down around her white face, which appears to be entirely drained of blood. She combs the wet strands with her fingers, flicks off the light, and retreats to the bedroom, pulling off her wet gloves.

Lucy is asleep on one of the beds, chin snuggled against shoulder.

"Hey," Carla whispers. "Did you notice anything a little weird about that shower?"

"I'm asleep," Lucy pleads, speaking in the monotone of the other side.

Carla is tired of sighing so she merely sits upon the other bed. One

good thing is that the necklace is not in the room but rather still out in the car, where it can mind its own business. Whatever business that might be. No doubt the hour is close to midnight, and they must rise very early for this jeep ordeal, and her body is exhausted. But her mind is not interested in considering sleep.

On the nightstand between the two beds is the book Lucy must have been reading. Carla picks it up: *Mysteries of the Canyon de Chelly.* Leaning back against the pillows, she idly flips around until a place seems to open of its own will: "The Creation Myths."

> Although the Navajo do not credit an afterlife, all of Hopi ritual is steeped in supernatural belief. This inclination of theirs offers strong support that they are in fact the direct descendents of the religious peoples who used to dwell in Canyon de Chelly's many pueblos. The literally thousands of carvings on the canyon's walls are generally assumed to have some sort of esoteric significance, and many of the more unusual pueblo sites are accompanied by kivas of mysterious design.

This is actually more interesting than she was expecting.

> The Hopi creation myth and the canyon art-work have never been very extensively compared, although some anthropologists have maintained that the connection is inevitable. According to the Hopi, there have been four created worlds. Currently, we inhabit the fourth and least appealing. Its name is Tuwaqachi, or World Complete. Its direction is north, its color is a yellowish white, and its metal is the mixed mineral *sikyapala.* In this world are the hardships and the sorrows of which the other worlds were freed.

Well, that figures, she thinks. Mixed metal is a sorrowful business.

Reading on, Carla discovers that in the third world, Kuskurza, the direction was east, the color was red, and the metal was *palasiva,* or copper. The third world was a time of wide-spread civilization, before there was destruction. "And yet civilization was what caused the world to go bad, for the inhabitants did not devote their days to communication with their cre-

ators, Taiowa and Sotuknang."

It is difficult for her to connect the concept of civilization with the metal copper—so uncivilized!—but she suspends her disbelief and continues. The second world, Tokpa, which was naturally before the third world, was the world of handicrafts and small villages. Its direction was south, its color midnight blue, and its metal was *qochasiva*. Silver!

Her body grows warm, either with memory or with fear.

> But the best world of all was the first world, where the first people lived in harmony with themselves, their animals, their creators. This was Tokpela, Endless Space, and important to it were the four-leafed plant, the fat-eating bird, the snake with a big head. In this world the first people were pure and joyful. Its direction was west, its color was dark yellow, and its mineral, of course, was *sikvasvu,* gold.

Well, that's about enough of that, she supposes. Carefully Carla closes the book and repositions it on the nightstand.

Tonight she wishes to sleep the deep sleep of the innocent, the ordinary, the sleep that floats the body as if it were only a feather, light and willing to waft upon the air, not composed of the minerals and metals and water which will forever anchor it to the rocks and the soil of the universe.

VIII

Carla stands in the icy morning air and waits for Lucy, who is still inside the room, primping and packing her daypack with necessary items. Such as the necklace. As soon as the necklace was brought into the room, Carla exited. The vibration is significantly deeper, more substantial, as though it were acquiring stronger powers.

Shifting from one leg to the other, she nestles her begloved hands into the pockets of her pink, hooded sweatshirt. Her sweatpants are a darker shade, and she is wearing her tennis shoes. A flowered bandanna pulls back her platinum hair, which feels thick and stiff in the cold desert morning. Or perhaps she has simply used too much gel. At any rate, she looks like something that ought to adorn a birthday cake; she feels like a fool.

And also out of place, irrevocably out of place in this remote Indian desert, preparing to descend into some strange canyon which houses undiscovered mysteries. Being here is ridiculous, but when she thinks back over the journey, at each turning point she would still have made the same decision.

Such is life.

Just as Carla is preparing to go back inside, necklace or not, and force out her friend, she hears voices and laughter from the other side of the lodge. When she shifts her gaze from the door of their room to the corner of the building, the European hippies from last night appear, walking two and two. The snaky-haired man is not wearing sunglasses at the moment, and now his face is visible. His features are large and squarely cut, his expression stern and groggy. He does not speak to the woman struggling to keep up beside him, who is dazzling in the early morning light, her rich auburn hair splendid against bone-white skin and a cobalt blue silk shirt.

The sight of these two together is inexplicably depressing to Carla.

The other two men, whom she can barely be bothered to notice, are the ones laughing and talking. They appear to be lugging suitcases and camera equipment along with huge backpacks. Because they are the designated sherpas, they keep stopping with their loads, exclaiming in what sounds like German, while their imperial leader and his consort stride ahead.

When the leader passes, he turns and nods at Carla. Or does he? She is sure for a moment that she has seen into his eyes—seen what?—and then she is just as sure the whole thing never happened. The other three in the party do not acknowledge her, but the metal equipment taints the air with its industrial, practical attitude, its odor of expense and efficiency. The group marches and struggles toward the far edge of the parking lot, which is probably where the jeep is supposed to be.

"Here I am!" says Lucy, one of those people who likes to get up in the

morning. Her daypack bulges with authority, and the necklace. "I think I've got everything we need."

Carla swallows her sigh—today she is determined to be a good sport. Lucy is wearing lederhosen and Swiss hiking boots and blue eyeshadow. The good news is that she makes Carla appear somewhat less foolish.

"Let's go!" Lucy wiggles her eyebrows like Groucho. "Don't want to miss that jeep."

They turn toward the direction the sun is rising from. The sky is a rosy, happy peach. The air smells like good news.

"Those hippies we saw last night just passed by. Looks like they'll be on the jeep with us." Suddenly with the air and the light, Carla feels almost happy.

"And you sure don't mind, right?"

Carla smiles and feels her face grow warm. Perhaps things will actually lighten up, perhaps this will be fun. This is a vacation, necklace or no necklace. And on vacations you do what you might not do otherwise. On the other hand, she feels the heavy dread of silver from Lucy's pack, and, as they round a clump of scrubby pine trees, she feels the humorless, high-tech energy of the Europeans' equipment.

And there is their ride—not a jeep but more like a truck, a huge metal truck in chipped army green. It looks like something left over from a war. While the Europeans stand around, smoking and bickering in German, Lucy smiles broadly and clambers aboard, leaving Carla with little choice except to follow.

The first contact of tennis shoe with metal stair is disgruntling but tolerable. The vibration is reasonably calm—masculine and not unpleasant, neither alien nor hostile. Gratefully, she positions herself on one of the two long benches that faces each other in the bed of the truck.

Her spot will be next to the tailgate, in case she has to jump out or something.

Lucy scoots down on the opposite bench so that she will be directly across from Carla. Their knees are about three feet apart; it should be easy to lean over and talk.

Perhaps because Lucy and Carla did not hesitate, the others now climb aboard. The two men with the equipment arrange themselves on Lucy's side, between her and the back of the cab. The auburn-haired woman hesitates for a moment, and then sits next to Carla. The snaky-haired man climbs aboard last, glances at the positioning for a moment, shrugs, and then assumes the remaining bench space between the auburn-haired woman and the cab. He pokes his hand through the flat plane of air that ought to be glass, into the driver's space.

The woman, who keeps sneaking looks at the snaky-haired man, smells of sweet, expensive, musky perfume. The only metal she wears is in

her ears, three hoops in one and two in the other, and it is all high-quality gold, clear and civilized. Casually, she flicks her hair, a beautiful Pre-Raphaelite shade which is anything but natural, behind her lobe. Everything about this woman is confident and chic, tasteful with a hint of the outré. Somehow, hers is the spirit most in harmony with the air, tangible as fine crystal, its luminosity strangely unaltered by the dust that the early morning wind swirls upward.

Leaning in a phony-casual way on her right elbow, Carla pretends to be absorbing in the view and not in her own increasing envy; helpfully, three birds soar overhead in the direct line of her vision, as if she had summoned them by her gaze. How pleasant to be a bird, she thinks, gliding down to the canyon floor in a manner of minutes, to the place at which it will take this truck the entire day to arrive.

The woman leans forward to address the equipment men opposite her, and from the corner of her eye Carla is aware of the close, unobstructed view of the snaky-haired German. Furtively, she scrutinizes his profile.

He is the essence of arty cool. The absolute purity of his demeanor goes all the way out into hyper-consciousness and back again. His face is square, with a strong, judgmental jaw, and the expression is marble, offering an appealing contrast to his hair and clothes, both of which move enticingly in the constant breeze. The dark hair is erratic and lively, looping and fluffing into capricious twists, and the shirt flaps like a flag of thick black cotton, a Romeo shirt with an open neck and billowing sleeves. His well-worn, flared cords are chocolate brown, and his feet are shod in cognac moccasin boots, the kind with leather ties twisted around silver buttons on the sides.

Wouldn't it be wonderful to be him? This man is not interested in looking rich or athletic or tan. He doesn't blow dry his hair, worry about the legal system, or care about what kind of car other people are driving. Probably, he doesn't have to concern himself with other people very much at all... and if all this is true, what does he concern himself with?

Why, what is artful and important, of course! But what is that? Carla is not entirely sure, but, at this point in time, she assumes it is not what her life seems to consist of—the reassuring of her clients, the constant maintenance of her flowers, the equally time-consuming tending of Michael's ego, the social nuances of the life that a prominent lawyer's wife will be expected to live.

Perhaps because he knows he is being watched, no matter how cagey she imagines her perusal to be, the snaky-haired man takes a pair of sunglasses out of the pocket in his pants and puts them on. Not the dark mirrors of last night, these glasses are perfectly round and tinted bottle-green, the frames an orangey tortoiseshell. They contrast effectively with his skin, pale from too much studying or a simple love of the nocturnal.

Now he looks both more mysterious and more stereotypically

Germanic. His hair winds out and away from his face, a fixed constant, Inquisitor, strong and pale and austere.

Abruptly, his profile shifts to full-face, a white trapezoid, and Carla suddenly feigns increased interest in the Arizona sky.

In a moment, Lucy taps her on the knee, offering a cigarette. They both know that Carla doesn't smoke, but, for some reason, no doubt relating to imagining one appears cool, she accepts. Her friend's eyebrows wiggle in amusement as she proffers her lit match.

Smoking a cigarette with her wholesome appearance, on first glance ironically the epitome of Aryan good looks, might present a peculiar contrast—doesn't she look like the type who loudly disdains nicotine?—but perhaps that also tells the true story, reminding the casual observer that you should always look more closely, that what you think you see is not always what is there. Illusion. Smoke and mirrors.

Well and good, except the thing tastes nasty, and she isn't even inhaling! Making a face and tossing the offending object might appear distinctly uncool, especially since the auburn-haired woman and the snaky-haired man have both lit up. Their cigarettes are rolled in brown paper, probably unfiltered and ten times as strong as Marlboros. The woman French-inhales, the disgusting and yet impressive trick of sucking the billows of smoke back up your nostrils, like a fire-breathing dragon in reverse.

Just as Carla is vaguely considering attempting to mimic this little feat (the dilemma being that if you don't inhale, how do you get the smoke?), a squat, dark-haired man in faded Levi's bounds up the truck's steps in one long leap of his cowboy boots, a kind of miracle. For a moment he regards the passengers with apparent amusement, as if they were not yet fully alive. His wrists and neck are wrapped in the dreaded silver, yet the muffled vibration is somehow sympathetic.

Then the Navajo guide—for this is what you assume he must be—picks up a clipboard from a shelf next to the tailgate and makes a few quick scribbles. He tucks a pencil stub into his front pocket and looks out over the passengers again.

"This here is what we call now the all day trip," he announces in a kind of drawling lilt, as if he has no real interest in what the words mean. "This here is your water now," he continues, rapping the large green can next to Carla, so apparently he is paying some attention to what he is saying. Until his touch, the can and its stored energies seemed not to exist; now they leap up in full bloom, as if his naming is creation. "And these now are your cups and this here is the trash can. We will be stopping now for two morning rest stops down in the actual canyon." He pauses and inhales deeply, as if in anticipation of some ordeal of which the others are as yet unaware. "And we are stopping where there are closets and ruins. Then we are stopping with the lunch bags provided by the Spider Woman Lodge. Up the canyon we take

maybe six hours, rest one hour, down the canyon maybe six hours. We are back at eight now," he concludes, and Carla has the funny feeling that they've actually already taken the trip, his speech is exhausting her, now it really is eight o'clock.

Time to go home.

One of the camera-carrying men next to Lucy raises his hand but the guide pretends not to see him. You can tell that he isn't really crazy about any of his passengers, but you can also tell that he is even less crazy about the Germans. His glance in their direction expresses unmitigated scorn.

"*Bitte*," the German says.

The guide swivels his head, slowly and menacingly.

"We are one camera crew," the German announces. He is blond and plain-looking.

But his tone of voice makes Carla's stomach contract: he is a master speaking to a serf.

"And it is necessary that many times we stop."

The guide pushes back his cowboy hat and adjusts his aviator sunglasses with a stubby forefinger. His face is inscrutable, a mask like the one that the snaky-haired man wears. And he is, incidentally, staring out over the rustling cottonwoods, unconcerned with this little exchange.

"We will be stopping now for two morning rest stops in the actual canyon." This time the intonation is pitched lower, like secret thunder.

The blond German makes an impatient movement with his hand. "We pay *gutt* for extra trouble."

Carla realizes she is holding her breath. Lucy catches her eye and grimaces, her expression revealing contempt for this somehow typically male power struggle, this problem with territory and control. Time passes while the guide holds the upper hand. He can make them all sit there and sweat it out.

So, he removes a bandanna from his rear pocket and casually folds and refolds it over one muscular thigh. He is like the professor who allows his students to watch him add sugar and cream to his coffee, stir and taste, before he will deign to reveal how they have fared on their examinations.

His gaze returns to the German, who appears oblivious to all of the intricate tensions. "Okay, you pay *gutt* all right."

And then he holds out the palm of his hand. And he laughs.

The Other Canyon

IX

As soon as the engine starts and the rumbling, lurching movement of the truck begins, Carla is in pain. This pain is quite simple, though: her bottom hurts. The dirt road is deeply rutted, and their guide is steering into the rut. Probably he is hoping to ruin the camera equipment.

The German next to Lucy who did not insult their Navajo guide, also blond but softer-looking, dressed causally in blue jeans, black tee shirt, and a beret, squats down on the floor of the truck, coddling several long instruments which resemble expanding metal spiders. His cheerful nature is evident in the way he laughs each time a bump sends him sprawling. He picks himself up and then falls right over again.

The snaky-haired one, dark and unreadable behind his bottle-green shades, nods at this display with a kind of benign condescension. Something which never actually becomes a smile plays at the corners of his mouth.

But then the metallic presence of the truck body begins to get to Carla, more so than the pain of her bottom or the antics of her fellow passengers. The vehicle has apparently accumulated more energy than was originally discernible, and this energy is gathering and coiling, like a warrior assembling his weapons. Stealthy and confident. The full extent of this power remains hidden; she only senses what they let her sense.

They?

Who are "they"?

No way to tell.

And, of course, she is not accustomed to traveling in public vehicles. A train here, a taxi there, but mostly she avoids them. You feel things you don't really need to feel. She only rode the school bus twice before her migraines helped her mother come to her senses. Once she touched an elevator handrail in a hospital while visiting a friend. Like the energy in most public places, it emitted the needlelike vibrations of a massaging showerhead. The level of involvement, except for the odd, saxophone-longing of the occasional malingerer, is very low. But there, in the hospital, she encountered another level of possibility—muscular, attenuated, personalities mixing as colors mingle in a Scottish tartan, as flavors mix in a simmering curry. Perhaps not as warm or cheerful as either the plaid or the curry, but not yet as despairing as you might think.

This truck is something like that handrail, with the addition of a purely abstract element, knife ring of fine crystal. Pause of anticipation.

In an effort to snap her attention away from the truck's pulsing, Carla forces her gaze toward the passing scenery. They are nearly at the mouth of the canyon, but you'd never know this unless you'd looked at a map, which Lucy made her do. The surrounding desert is the same uncompromising mud-

dust brown as it was on the drive into Chinle, the scruffy cacti only attractive to the most passionate aficionado. Low-lying lumps which are not even exactly hills repeat themselves like a stuck record. Suddenly the truck veers toward those lumps and away from the road.

On the far side of the lumpy area—much bumping to the bottom—is a muddy stream. Two little boys ride bareback on an old mare, and they do not bother to look in the truck's direction.

The truck lurches, with an abundance of heavy dust, down a rutted incline; the jolly blond German falls flat on his side, *ooph!,* and a fine spray of water splashes over the seat back. Carla flinches—the water is sharp and hot, a message that dries on the air. Crunch and lurch of truck gears.

In fact, the truck stalls out. Only then do you realize how utterly, perfectly quiet it is, preternatural, the mouth of the canyon rising up before the travelers, open in a prayer of silence.

And for a long, cool moment, nobody moves. A shock of birds sprays out from a stand of cottonwoods, soundlessly swooping over the flat brown water that the truck seems to be floating in. The shallow stream parts and diverts itself about the foreign mass; the water only flows at this time of year, melting snows from somewhere at this moment unimaginable. By mid-summer, what is left of the water goes underground, carrying its secret burden beneath the sands that shelter it. And sometimes the water is dangerous: floods and quicksand. But mostly its cool presence is reassuring.

Now the two boys and the horse have stopped and are regarding the truck, as if they expected it to do something interesting or important.

Lucy and Carla exchange looks; they are both filled for the moment with a sense of awe. The silence. The water. The pattern of the birds.

From the backpack the necklace seems to shimmer approvingly.

Their guide and driver mutters something in what one assumes is Navajo and the truck sputters awake. He glares through the unglassed rear window of the cab at the Germans; obscurely, whatever may go wrong is all their fault.

Startled out of her wimpy self-pity by this brief interruption, Carla remembers the other passengers. The auburn-haired woman now seems to shield or guard the snaky-haired man, probably from the banality of the Americans; she is always touching his thigh or patting his shoulder. In addition, she flirts with the two blond men, throwing her head back and laughing at a chance remark, the skin on her throat as pale and thick as buttermilk.

His face unmoving as that of a statue, his hair swirling in Medusa-like coils, the dark German pays no attention to his crew.

And yet the woman is so lovely, so casual and arty! Against the bright cobalt blue of her sleeveless silk blouse, her arms gleam, neither plump nor thin, simply appealing flesh. Her hair glows red in the sunlight, curling and winding, as if it were never set or styled but merely ruffled by hand, falling

The Other Canyon

by dint of texture and the perfect haircut into its own alluring shape.

That's real freedom, Carla thinks—never combing your hair. Waking up in the morning without checking the clock, and smoking a cigarette before getting out of bed. And your bed is a mattress on the floor in a room full of paintings and interesting, unusual objects. Perhaps you will don a pair of splattered jeans or a silk kimono—you are too absorbed in the fascination of your own thoughts to care. You do not brush your teeth every time you turn around. You do not pick snails off your flowers or even water them. In fact, you do not have a garden—you live in a big city in a loft and your flowers consist of cut, hothouse varieties purchased by your whimsical friends.

You do not worry about jewelry or metal. Ever. You do not even think about it. You are different because you are a free spirit, not fettered by the shackles of daily life. You are different, but you are not strange.

The auburn-haired woman assumes a pair of huge square sunglasses, the kind that foreigners consider American, and they actually do lend her the look of a Hollywood starlet. Her lipstick is blood-black this morning. Besides the five gold hoops, her only jewelry is a beaded leather necklace which has been wrapped nonchalantly around one wrist. *Wear a necklace as a bracelet*, Carla mentally records, as if giving herself tips on how to be unconventional. Also—

"Excuse me," Lucy leans down to address the good-natured blond man, who is on the floor between the two benches, trying to contain his equipment. "What are you all doing here?"

The truck continues down the middle of the shallow riverbed, following it as if it were a road. Things are less bouncy for the moment. Rubble heaps which must eventually transform themselves into canyon walls gather and thicken on either side.

The man smiles, his sandy shoulder-length hair and pale eyes likable because of his apparent good nature. But he shrugs and turns back to the less pleasant blond.

"We are fil-ming," this German announces to Lucy. His features are even and clean and his complexion is pellucid. A mustache the color of Carla's hair completes the face, which is aesthetically pleasing and yet somehow unattractive.

"I gathered that." Lucy's large green eyes are beginning to sharpen, and if you knew her, you'd be wary. "What for?"

"One film." His body remains politely tilted toward Lucy, but it's clear he is not interested in the conversation.

"What kind of one film, exactly?" Now her eyes are dark as a forest just before nightfall.

"One artful film." Now Blond Mustache swivels his body away, as if closing a door.

"*Es ist* ex-peer-men-tall." The snaky-haired man makes his pronounce-

ment without looking at Lucy. In fact, he is staring directly at Carla, his glasses shining like green quarters. This distresses her so abruptly and suddenly that she leans back against the bench—big mistake—just as the truck careens into a river rock. Ugh.

"Are you the director?" Lucy asks.

"*Ja.*" He is still staring at Carla, who keeps her eyes straight ahead.

"I'm Lucy and that's my friend, Carla."

"*Ser erfreut,*" he says. "*Ich heibe* Joachim."

His hand reaches over and pats Carla's knee. He has had to reach around the other woman to do this, and she smiles stiffly, clearly wishing all Americans dead.

Nodding at Joachim but not daring to actually look in his direction, Carla gives her knee a little twitch, which is emanating a warm vibration. The hand remains implacable. But more uncomfortable than its sudden fixedness, which is growing increasingly embarrassing, is the heavy signet ring on his second finger. The object is as large as an official seal, and the energy is very old and commanding. Although it must be brass or bronze, it has none of the usual dull anger—instead, it is hard and imperial, like a ring once worn by Martin Luther.

And that's what Joachim suddenly reminds her of: some humorless religioso, an imperturbable watchdog in the dead center of life. Not cruel, but not necessarily compassionate: the great rock which the river must find a way to flow around.

Balancing herself against the metal bench, backs of her thighs pressed into the sharp edge, Carla stands upright in the bumping truck. "How lovely!" she exclaims, pointing nonspecifically at the scenery.

The heavy hand reluctantly slides away.

The scenery has, it seems, conveniently complied with Carla's need for distraction and extrication. Sheer cliffs of red-orange rock are now rising up on either side of the shallow river; a dusty clump of cottonwoods sways in the morning wind. Oddly enough, these cliffs which embrace the truck like surrounding arms do not seem claustrophobic. The rock refuses to reveal its grander dimensions, which is intrinsic to the nature of all spectacular monuments. As the truck jounces on, all sense of proportion is increasingly lost. The cliffs might tower two stories or twenty or two hundred; the only thing measurable is the possibility of climbing out.

Carla plops back down, hoping her gesture has somehow clarified her position… now, if only she knew what her position were!

"A documentary?" Lucy asks Joachim.

Not wanting to participate in that conversation, Carla directs her attention to Blond Mustache. He smiles at her in a manner bristling with sexual innuendo but devoid of any real content. Unlike the others, this man does not appear artistic. His dark brown shirt and khakis are well-pressed, military in

their startling contrast to his pink and white complexion. Except that he somehow remains unappealing, in many ways he is Carla's male counterpart.

"My name is Dieter." His accent is slight. He points to the jolly cameraman, who has once again sprawled flat, sandy hair flying. "His name is Wolfgang."

Wolfgang looks up and tips his magenta beret. His blue jeans manage to be both very old and stunningly tight as if they had bonded with his skin. His black tee shirt proclaims: I'M A COONASS AND PROUD OF IT.

"Her name is Solange," Dieter continues.

Now Carla must turn her head and smile at this woman who is, worse luck, French. Her face is expressionless, eyes obscured by the large sunglasses. She and Joachim seem to form, by their veiled visage, a kind of secret club, and Solange, at least, is not interested in any new members. Yet why should she worry, exotic specimen that she is, her titian hair, her white arms protruding like delicious *baguettes?*

"Wie geht es Ihnen?" she asks politely. A French woman who pretends only to speak German, perhaps.

"Is your film a documentary?" Lucy asks Dieter. Whatever Joachim said was apparently unsatisfying.

"This film is not one documentary," Dieter replies. "I produce this film and Joachim directs this film and Wolfgang cameras this film and Solange orders this film."

"Who does the acting?" As soon as she speaks, Carla feels her face grow warm, intuitively knowing that this is somehow the wrong question. She can feel her skin turn the rosy color of the passing canyon walls. White hair, pink sweatshirt, china blue eyes, red face. However, this confection is only her body.

"We are not needing actors," Dieter says coldly.

"Ac-tors!" snorts Joachim from his corner. Then he speaks rapidly in German. He and Wolfgang and Solange all laugh merrily and Dieter allows himself a thin smile.

Lucy leans across the truck, her body at a cantilevered angle supported by forearms on knees. She pats her friend's gloved hand and then sits back, lighting another cigarette.

Carla, shaking her head at the silent offer of another smoke, carefully removes the glove on her right hand. When her fingers are free, she touches the platinum chains at her wrists and throat. She has allowed herself to be distracted by a handsome face, and it is time to remember her priorities. As if offering a reprimand for forgetting, the platinum is flat at first, but then its essential metal nature course through her, an icy stream, fresh mint, watercress. Wallace Stevens.

"What, exactly, is so hilarious about actors?" Lucy has swiveled to her right in order to face Dieter directly. Her arm is extended menacingly along

the back of the bench, and her face is arranged into lines of cold fury.

"Actors are *passe*," says Dieter.

"Oh, well," says Lucy. "*Pardonnez-moi!* I have an M.A. in Art History from Berkeley. I only teach art every day of my life. What would I know?"

Dieter looks grim. "Teachers are *passe*."

Lucy's face begins to turn an angry purple, like a thunderhead amassing, and just when Carla thinks she will have to intervene in a drastic manner, the truck abruptly lurches to a halt.

Once again the moment is eerie silence, preternatural. Everyone exchanges surprised glances; no one has seemed to remember the actual canyon, the physical world, the reason for anything.

The guide hops out of the cab, circles the truck, and props one foot up on the metal stair-steps that lead down from the rear, between Lucy and Carla. "My name is John Johnson," he announces, as if the passengers have never seen him before. "We are now at the first sight of pictographs. Drawings in the canyon are some pictographs, some petroglyphs." Once again his voice is lilting, seemingly without interest in the meaning of the words. "Pictographs now are some color mixed with some liquid—"

"Usually urine," says Lucy.

"—and petroglyphs are out-carvings. This here in the canyon now we have both." Johnson gestures to his right and every head swivels in that direction.

And all you can see is the great pink-orange cliff, expansive and contemptuous in the daylight.

Wolfgang extracts a pair of binoculars from his pile of metal equipment and studies the cliffside for a moment. Then, his smile kind on his plain, sweet face, he begins to hand them to Lucy, but she has already extracted her own, and offers them to him. They smile again and shrug.

Lucy proffers hers toward Carla, but she also shakes her head. No more metal at the moment, thank you very much.

"These are markings made now by the original peoples," Johnson continues. "You see the hands sprayed outline. This could be the first ritual stop now. The Anasazi marker to the canyon entrance." Almost against his will, some interest in the subject has begun to creep into his monologue.

"Excuse me," Carla says. What has gotten into her? Words are clogging her throat like ball bearings.

Johnson stares at her. With his aviator shades, he is the third member of the veiled-eyes organization.

"Excuse me. Was this a religious site?"

Johnson looks at her with the kind of lack of expression, perfect total lack, that must involve both years of conditioning and hours of practice in front of a mirror.

A good minute passes.

The Other Canyon

"No religious site in this canyon now."

"But they say, you know, that here…" Carla trails off lamely. Exactly what did that book say, anyway? Besides, he knows precisely what she means—she is sure of it.

Johnson chuckles in phony tones. "Yeah, all these stories the Navajo make up so rich tourists pay the Spider Woman Lodge for the all-day tour!"

You wonder who he expects to laugh at this joke, and surprisingly it is Dieter. Politely, the other three Europeans smile along.

Carla and Lucy continue to look at Johnson.

And then Solange interrupts. "*Das ist…*"

The others follow the direction of her pointing finger, away from the cliff and toward the center of the stream. The cab of a truck sticks out over the top of the water like a turtle's head; the remainder is no doubt well-stuck beneath the deceivingly serene surface.

"Anglos," says Johnson cheerfully. "What happens when you come into the canyon without guides." His smile widens until his mouth looks broad and froggy. Probably he is just joking, enjoying his day of power over his captive passengers, and yet there's something about the way his chin is thrust forward that indicates otherwise.

"No religious sites in this canyon?" Lucy's smile has shrunk, rodent-like, as if mouths and points of view are necessarily diametrically opposed.

"There are two canyons now." Johnson resumes his chant, holding up two fingers. "Canyon del Muerte," he says and slaps one finger with the other hand. "And Canyon de Chelly." He slaps the other finger. "First we are going up Del Muerte to Antelope House Ruin." He pauses. "Antelope House Ruin," he repeats, as if everyone were taking notes. "On we go up then to Mummy Cave."

Surprisingly, Johnson is suddenly interrupted by the arrival of another truck. Where on earth has it come from? Instead of the two long, facing benches, this truck has its bed divided into four rows, and each row seats three passengers. The dozen bodies face straight ahead; the riders sit primly, well-behaved schoolchildren.

Their approach has been almost uncanny. No warning, and then they are there in a slight swirl of dust. Gaudy sunhats and much glinting of sunlight off metal objects: binoculars and jewelry and cameras. When the new truck stops, a very short guide hops out of the cab and stands on the ground. There are no steps at the rear of the truck for him to lean on, and, even if there were, it would be difficult for so many people packed so closely together to swivel around to view him. He remains just to the left of the cab, but, because he is so short, perhaps only five feet or so, everyone must crane his neck downward, awkwardly. The guide's diminutive stature does not lessen his showmanship; he swaggers in his cowboy boots and large white hat.

Without a glance at Johnson or the truck already in place, the new

guide beams at his cargo. "We are now at the first sight of pictographs," he intones in the same familiar cadence. "Drawings in the canyon are some pictographs..."

"Know why he's so short?" Johnson asks his passengers rhetorically. The new guide's arrival seems to have had a bracing effect on his mood. "Part Hopi!" He guffaws. His teeth seem to have seen better days.

No one laughs at this joke, not even the obsequious Dieter. Perhaps the subject of territorial rights is not amusing to the Germans; certainly, Carla does not catch the gist of Johnson's merriment. Once Mr. Powell hosted a reception for Norwegian jewelers, and someone told a nearly interminable joke, the punchline of which was: "'All for Norway!' shouted the man as he pushed the Swede overboard." The Norwegians had collapsed red-faced in laughter.

The Hopi, if that's what he actually is, shoots Johnson a brief, self-conscious look.

"Now the original peoples," Johnson resumes, barely controlling his mirth, "cultivated squash"—again with the fingers, this time three: slap, slap, slap—"and beans and corn. Then..."

Carla tunes him out. More Anthropology. The sun has become increasingly hot during these moments of stillness, not so pleasant, and if she could get out of the truck and away from all this metal, she could take off her other glove and her socks and her shoes. It is too warm to consider protecting her extremities, and she is at the point where she has forgotten the point. Whatever energy the truck contains seems to hum angrily inside it, as if wishing her up and off and out. Fantastically, she imagines just springing free somehow, simply fleeing. This is the feeling you have when you are in a crowd and not feeling well, you are nauseated or faint, and yet from the outside you appear to be okay. No one else can tell how badly off you are. And, once you realize that no one else knows you have a headache, are in major pain or heartbreak, you think that perhaps your illness is false after all—who can ever measure or detect what you are feeling? Perhaps this is illusion, the vague product of your own foolish imagination...

Johnson hops off the steps and jerks Carla back into the moment. He climbs back into the cab, and they're off again: lurching of gears, bump bump, painful bottom. The heat and the motion and the queasiness.

"Here." Lucy hands over the water bottle, thoughtfully plastic, and the aspirin bottle. So much for that theory about nobody noticing.

Joachim and Solange are chatting gutturally, Wolfgang is trying to rearrange the equipment, and Dieter is staring fixedly at the cliffs. No one is paying any attention to Carla, but that doesn't matter. She cannot swallow pills if anyone is present. Her throat would pinch together like modeling clay, the bitter nastiness of the aspirin causing her to gag.

She splashes some of the innocuous plastic-water onto her face and

hands the stuff back to Lucy with a thanks. It is good to have a friend.

"A bundle of nerves." Lucy gazes cliffward. The great, weird pinky slabs of rock are already assuming the look of normalcy, as if that's the way the whole world is. "A good thing you look healthy, anyway." But Lucy's voice is fading away—she doesn't seem to be paying attention anymore. Her face is, for once, calm and reflective. Already the sun is tanning her olive skin, even through the protective coating of make-up. Her green eyes seem to be regarding something beyond the cliffs, something larger and more imposing.

Resigning herself to a certain level of carsickness, Carla leans back and forces herself to relax, to make an attempt to enjoy the canyon unfurling before her. When will she ever have an opportunity like this one again? The cliffs are so massive by now that, as the truck progresses inward and downward, you get the impression they are huge living entities, like Titans, slowly uncovering themselves, disrobing, revealing the impossible immensity of their depth. When the truck passes into the shadow of the rock, the air is icy.

Down, down into the heart of it all. The necklace continues to make its presence known, its harmony with the flecks of fine-grained metals that flicker in the canyon walls; its energy floats suspended in the canyon water. Above and beyond the crunching of the truck and the babble of conversation, the cliff walls loom frozen and complete.

Have they stood here forever?

In early spring, the river rages fierce and full. By early summer, the water is sluggish, as it is now, but sly and dangerous. By late summer the riverbed is dry, the forces covert, diverted. In autumn, the Basket People supposedly left the canyon until spring. This is the same pattern claimed by the scattering of Navajo who still live down in the canyon.

And there are the old pueblos that the Basket People inhabited for half of the year.

First you see only a few, glowing like moonstones, wedged in niches halfway (an enormous climb—how was it ever accomplished?) up the walls. Then you see more pueblos, more clusters of pueblos; then there are dozens. From this vantage point they look fully intact, as if they had only been abandoned yesterday. They are triumphantly unexcavated—too far away, too hard to reach, too delicate because of crumbling adobe.

Or perhaps they do not allow themselves to be tampered with.

At whatever cost, the pueblos remain, pink and pearly, window holes for eyes. In the winter when it is ten below in Chinle, it is fifty below down here. Who would dare endure?

The canyon waits. Just as a fallow field is being replenished by the rain and the wind and the plants, the empty canyon is being restored.

Carla stares at the cliff face. Her head and body truly ache, and she is fully nauseated from the jolting of the truck. A dull drone seems to be lifting the top of her skull. Inside protective layers, her hands and feet sweat pro-

fusely in the blast furnace of the desert.

But something moves, a devil of dust, a shadowy form of ectoplasm in the chill shade behind the cottonwoods. What does she see that shimmers like ghost writing before her eyes?

Blink and it's gone.

Whoever lives here may move or relocate, but here is something of which she is very sure: they never actually leave this canyon. Not then, and not now.

X

About an hour later the truck pulls out of the riverbed and over to one of the sandy banks, under a clump of cottonwoods. As soon as the wheels grind to a halt, Carla leaps out. The ground, after the fuel of the metal in the water, is like ice on a burn. At least it isn't frying pan into fire.

Her whole body is aching and she feels extremely sorry for herself. Paying no attention to anyone else, she walks over to the river's edge, and removes her remaining glove and stuffs it into her pocket. Why bother to be cautious any longer? This situation is unlike any she has ever been in, and there is no escape. Now is the time to discover the new rules for surviving.

The sandy river bottom is as flat and clean as a brand-new aluminum cookie sheet. Carla pulls off her tennis shoes and socks and slips her feet into the sweet, muddy waters.

Everything is as still as heaven. Then, accompanied by the waft of verbena, cicadas hum. Mid-morning nap time.

"A good idea," Lucy announces, behind her. "But how come you aren't having a hissy fit?"

Carla glances over as her friend wades up next to her, the edge of her silly lederhosen dragging wet. Actually, she would make a charming photo, but Carla, not surprisingly, has never owned a camera. "I made a decision. Now I'm testing it."

"Want to talk about it?"

"Only if it works." Carla begins to edge backwards, up to the sandy bank. Everything on the ground, in fact, is sand, pale and fine as her hair. Now the sun doesn't seem so intense. Now she imagines that there is something in this air, this unique combination of land and wind and heat, that might heal her—if only she could be certain where the wound was.

Lucy looks back over her shoulder, focusing beyond Carla. "What do you think of The Dark God? I can tell you what he thinks of you."

Carla looks back too. Johnson and the film crew are walking away from the river and over toward the ruins, which are the ostensible reason for this stop, and the outhouses. Their equipment jangles like an excess of pocket change. "Do you think they're going to try to film right now? I thought this was one of the short stops, though I wish we'd stay longer."

"I see we're going to be evasive." Lucy joins her friend on the sandy bank. "You want to see if you can swallow the aspirin now? I'll go away."

Carla shakes her head. Now she feels fine—actually fine, though of course she might feel even better if she knew exactly what was going on. Or what she was doing. Or what was or wasn't working.

The muddy surface of the water gleams.

"Do you think it's time for the necklace?" Her hands start to sweat.

Lucy squints against the sun. "More importantly, do you?"

The feel and thought of the necklace are almost not unpleasant. How peculiar. Is she changing, or is it? "Maybe the farthest point would be best."

Lucy spins on her heel, a 360 degree inspection. The panorama seems to please her; her face, growing bronzer, is arranged into lines of joy. "Sounds good. God, I'm so glad we came here—"

Carla's lips curve in agreement. Suffused with a rosy sense of well-being, they put their shoes back on and head for the others at the Antelope House ruins. The second truck has just pulled up, and it occurs to Carla that this is probably the half-day tour. Perhaps they will be turning back soon.

The Antelope House ruins are bleached and dusty, not as attractive as those pueblos which smile enticingly from the cliffside. Several different adobes, shockingly small, are clustered together, their sides artfully half-collapsed to allow an interior view. It almost appears that this model ruin has been deliberately located right here, situated conveniently for the curious tourist.

Carla scans the official sign for this landmark. In the universal, impersonal wording of historical sites, the sign explains what life was like for the original peoples, the cliff-dwellers, the Basket People, the Anasazi—whatever you care to call them. They raised corn, beans, and squash.

The sign depicts them as a cheerful people, climbing up and down their timber ladders, tending to their wholesome work with light-hearted industry. Weaving their baskets. Grinding their grain. For the historian, the simple past is an eternally jolly thing.

Carla rotates back to face the flat, muddy surface of the river, trying to imagine what it had actually been like. Clean and simple in some ways, of course, but what did you do at eight o'clock on a Saturday night? No seven-course dinners at Ambrosia, Michael's favorite restaurant. No *pate de fois gras*. No vintage champagne. No opera or ballet. No Saks, no Neiman-Marcus.

On the other hand, no cars, no telephones, no electricity. No computers! Instead of gold and diamonds, everyone would be wearing silver and turquoise... or would they? Oddly enough, now that she thinks about it, that's not the energy sense she gets from the canyon at all. Unlikely as it seems, the atmosphere is more like... platinum.

Carla shrugs and turns back to watch the Germans tinkering with their cameras. Wolfgang is trying to set up one of the complicated tripods and Dieter is correcting him. Lucy is nearby watching. Solange is also standing nearby, but she keeps glancing away, toward the trees, where Joachim must be.

Carla is on slightly higher ground than the others, and maybe fifty feet away. She follows Solange's gaze toward her left, toward the trees, and she can see what they cannot see: Joachim using one of the outhouses. He has left

The Other Canyon

the door open, revealing his fully clothed back, and he is definitely urinating.

A little sexual trill surprises her in its shiver from crotch to abdomen—why?—and yet she is also repelled by his crudeness. Surely he knew that someone might see him; he must not have cared. And still she continues to stand there watching him, and, of course, he turns around, zipping his fly, and he sees her.

Joachim smiles.

Carla gives him her ferret face, and then, cheeks warming rapidly, walks down the slight hill to join Lucy.

But her friend has become engrossed with whatever these people are up to. Even ten feet away, her enthusiasm is tangible, like a force field. She would like to be involved, operating the cameras, organizing the crew.

"Look," says Carla. "I've decided to leave with the half-day truck."

"Then you better have wings. It already left."

When she looks over to the spot where the trucks were, sure enough, only theirs remains. A low dust cloud is visible, moving back over the river, in the direction from which they have come.

Unsummoned tears appear at the corners of her eyes.

"Come on," says Lucy. "I thought you were getting tougher? I've been so proud of you."

"Maybe I'm just thirsty." Carla tries to pull herself together as she walks back to the truck. Why has this weird attraction to Joachim thrown her balance off? What happened to that good feeling from standing in the water?

Nothing is certain; everything comes and goes.

Johnson is leaning against the tailgate, by the steps, smoking a cigarette. "Now," he says, handing her a paper cone of water. "You are asking about the Old Ones' religion." His smile is wide and bad-toothy; probably, he intends to humor and mock.

And yet she can perceive that she is making him nervous, somehow. The tension of his body is the stagey ease of the dancer whose steel muscles grip each line of illusory relaxation. A necklace, almost undetectable beneath his shirt, glints in the sun.

"Actually," she says, feeling stronger again, "I'm more interested in jewelry."

He smiles but his muscles flinch ever so slightly.

"May I touch?" Carla extends her hand toward the necklace.

Johnson swallows and nods.

Gritting her teeth against the inevitable jolt, she touches a large silver bead near his throat. The strong energy is venerable, ancient oak trees, but hostile, mountain lion. There is a river of rage, yet it is thick and controlled; this necklace is the tip of the iceberg, and the glacier itself lies in the waiting in Lucy's pack.

Respectfully, Carla withdraws her hand. "Lovely work," she says,

obscurely ashamed. "I'm kind of a jeweler." This remark, which was supposed to make things better, seems only to succeed in sounding particularly foolish.

"I am a silversmith," Johnson announces with dignity. "But there's no silver no more. We left this Anglo to run our shop in Chinle. So he runs off with all the stuff. Ten thousand bucks worth of stuff! When he left, he burned down the shop. Now all these rich tourists go to Hubbell's. So I end up guiding rich tourists through this here 'Holy Canyon.'" His voice is heavy with irony, making it clear how much stock he puts in the holiness issue.

"Why weren't you running the shop yourself?"

Somehow, she has hit the nail on the head—his face goes from grinning to closed again. "Because we was, uh, too busy."

An awkward couple of minutes pass. Carla is thinking about the burned down trading post, the stolen jewelry, the necklace, the trail that has led her here.

Will another trail appear to lead her out?

"Are we leaving soon?" she asks.

"Goddamn Krauts," Johnson says and walks off toward the Germans.

Wolfgang is still struggling with the tripod.

Carla empties her paper cup onto the sand; she is not willing to risk the pungent truck water. Then she sighs and puts her gloves back on. She can hear some shouting and some promises for a longer lunch break. Better get this over with, she decides, and steps onto the bed.

Now the vibration has acquired more emphasis, a broth growing pungent while simmering. On the other hand, she is becoming familiar with her opponent and can therefore more easily rally her defense. In fact, something about the vibration is almost welcoming—and that's dangerous, because she might relax.

They always get you when you relax.

Carla perches on the edge of the bench, back rigid, keeping herself alert.

Lucy climbs aboard and the Germans clamber after her. The complex metal equipment, evidently not actually employed during this brief rest stop, bangs and scrapes as it is dragged up the steps. Solange sits next to Carla, and Dieter, smiling coldly, sits across the way again, next to Lucy. Wolfgang is, naturally, between the benches on the floor.

Joachim is the last one to arrive. He stands at the top of the steps for a moment and then positions himself in front of Solange.

"*Ich glaube, das ist mein Platz.*" He regards her coolly, expecting his wish to be humored.

She sighs loudly, a kind of exasperated hiss, and then she slides over, away from Carla, and keeps on sliding down the bench until she's in the corner, leaning against the back of the cab and the hole where the window

should be.

As the truck clangs into gear, Joachim is sitting very close to Carla. She can smell his ring. She can feel, with each pinpoint of skin that yearns toward him, a fatal chemical pull. And as the truck begins to move, she tries to ease as far away as possible; in the hot sun his body aroma, strong but not offensive, confuses her.

After a few wild lurches, the truck stalls out. The passengers remain frozen, staring straight ahead like dummies, not wanting to acknowledge the hesitation.

After a string of muttered curses from the front, the truck once again springs to life, and they are all jouncing through the shallow, muddy water, moving through the pinky orange womb that welcomes and entices them, a swan or Siren song. How close they all are here in the truck back, how random the proximity; their lives are forever intimately connected, a handful of luminous fibers, and the huge silence of the canyon must needs divide them.

Gingerly, Carla leans back, using her shoulders to brace away from this strange man. But the truck hits a pothole; like a cartoon, their bottoms hover inches away from the benches and then slap down hard again.

And now Carla finds herself hemmed into the corner with Joachim pressed firmly next to her. Their thighs are cozy, like a matched set.

Very cute.

Very awkward.

And yet, it appears that no one on the opposite bench seems to notice anything unusual about this sudden closeness. Dieter and Wolfgang are bickering in German. Lucy is scrutinizing the view over her shoulder—on the other hand, her cheek muscle is oddly bunched, as if she were attempting to conceal a grin.

What should Carla do? If she turns her head to ask him to move over, his face, his lips, will be *right there,* and that's no good! A spring winds up in her stomach when she imagines that. Sliding her eyes to her left confirms what she already guesses, anyway: he is fixing her with his gaze.

The only solution, or so it seems, is to ignore him then, him and the little trill in her pelvis. She swivels away as best she can to stare out the back, to stare at the way out of the canyon, the passage they are leaving rapidly, too rapidly, behind.

A falling star glided down along the horizon. "There went one," said he, "but for all that, there are enough left. I should like to look at those things a little nearer, especially the moon, for that won't vanish under one's

XI

Now, with this strange chemical pull being exerted on her body, Carla begins to think about Attachment and Involvement. Oddly, it never occurs to her to think about Michael, the man to whom she is engaged to be married. Later, when she begins to feel guiltier, she will remember him.

But not now. Now she recalls what you give away when you begin to love someone.

This is what Carla thinks about.

She is fifteen.

She stands in front of her homeroom twenty minutes before school begins. The corridor is not very full yet, and she feels self-conscious in the bright fluorescent lights. Usually, she doesn't get here for another ten minutes—but Mother had a meeting today. Usually there are several girls who look like her already clustered together for the day. They spend their days in clusters.

Because she is pretty, nice, and buys the right clothes, Carla is just popular enough to feel comfortable, but not so popular that she needs to worry that someone will notice anything strange about her. Today she is wearing Guess jeans, a pink Guess tee shirt, and pink high-top Reeboks. Her blond hair has been carefully curled and moussed and tied back with a strip of lace, sort of like Madonna. Unfortunately, the jeans have little ankle zippers that have begun to annoy her—why is no one else bothered by wearing zippers? Her make-up appears wholesome and natural, though it takes her almost an hour to achieve this look.

She leans against the brick wall, mercifully grounded. A Hello Kitty purse weighs her down on the right side, and her books are propped in front of her like a shield.

And then André comes down the hall.

André is older, seventeen or maybe even eighteen, and yet he is only a sophomore. He has arrived at Newport High from some exotic place, France or Belgium, and although he has been here for several months, he has no friends. No one talks to him except the teachers. He is too smart for his own good in French class; Carla has seen that in action. Smart-ass is okay, but anyone who goes around quoting Baudelaire has only himself to blame.

Especially since he is not thin, pale, and dark, not Goth or Punk. He doesn't even look intellectual. Where would he fit in? His skin is rosy and his eyes are pale blue, maybe too pale. His nose turns up boyishly, yet his body is surprisingly thick and masculine, more mature than that of his alleged peers.

She always avoids him.

But right now there is nowhere to go. And, just as she had somehow known he would, André approaches Carla, as if he had been waiting here this morning for this express purpose.

"Hi," he says, smiling, confident of being welcome. "You want to go to a movie sometime?"

With hideous clarity, Carla knows that she does not. "Sure."

"When?"

"Uh, well, I don't know…"

"Saturday?"

"Sure," she hears herself say again, and she is appalled. She gives him her phone number.

"I'll call you," he says.

Only at this point in her life does Carla become aware of the telephone as something other than that thing which gives her a headache when she uses it. Although it is painful to employ, it has always functioned reasonably well as a convenient means for communication. If her friends do not call her, then she calls them. No one seems to pay much attention to who does the calling.

This time, it doesn't work that way.

Mother's Law forbids that she call André and ask, Are we still on for Saturday? Why are we going out? What do you want with me, anyway? When and why should I be ready? Since this is the eighties and nobody has a cell phone or a pager yet, her only option seems to be becoming a slave to her house. Suddenly, many of her usual activities—walking by the beach, having a snack with her friends and lingering as long as possible—are double-edged. For a day or two she haunts the house, and then when she gets disgusted and makes herself go out, Mother tells her that some person named André has called. And he said he'll call back in an hour.

Naturally, he doesn't.

Finally, he does call, around five o'clock on Saturday afternoon, after she has already agreed to go to the movies with her friends.

"I'll pick you up in about an hour," he says. Does he even consider that she might have forgotten or changed her mind?

"Cool," she says, all good cheer and girlishness. By constant daily examples, she has learned never to reveal her doubts or her fears, whether worthy or silly.

André, of course, has learned the same thing.

Nauseated, she waits in the hallway, afraid to wait in the living room for fear that he will see her through the curtains, as if the condition of waiting were shameful. Now she is wearing her best zippered jeans, black, and short black boots with spiky little heels, and a slouchy top in pink, very *Flashdance*. This look is somewhat trendier than her usual look, but fortu-

The Other Canyon

nately her mother is not there to point that out. Her gold watch rests on her wrist, not at all trendy in design, but the comforting feel of it is her only touchstone.

As if she were about to be cast adrift in the sea...

Her make-up and hair are impeccable. Mouthwash and antiperspirant. Freshly shaved legs. A slap of "Charlie" fragrance.

And the disgusting, flattering feeling of being inexplicably singled out.

He is right on time and dressed, for once, quite neatly in khakis and a decent blue shirt instead of the paint-streaked jeans that he habitually affects.

Carla is grateful for this show of effort.

And more wary than ever.

As soon as the date is over, the world is changed, not necessarily for the better, forever. If you are a self-enclosed entity, snail-smug in your round little shell, you may be very shaken actually to encounter another entity. Maybe you don't like lips on lips, but you will long for it as soon as it's over. You will long for that arm flung possessively around your shoulders even though it seemed to shackle you when it was there.

And those songs on the radio? You thought you could go on not paying them any heed. Now their tinny generalities are magically transformed to profound observations about human behavior. "Every Breath You Take" becomes the stuff of nightmares.

The stuff of nightmares and all the daydreams as well, the body-memory that wants to replay *just how it was that he touched me there.* And then, at the same time that the body is replaying all of that—a kind of continuous backnote music to whatever form of living is going on in front of you—(and this is the part that might save us, nemesis and salvation) another spirit works through your blood and tells you: you can have this world, this dense oily water... but then the other world will begin to recede.

The other world. The world in which you do not have to be conscious that your body is distinguishable from the luminous hull of the universe. The world in which you wake each morning in the clean air, with no sorrow and no expectations.

Even now she must remember the little shrug of pain when she thinks of André, his well-meaning but failed intentions, his own vision of himself as the irresistible, sensual *artiste.* Her friends seeing him at the movies with another girlfriend. Carla hating him at the same time she wants to defend and understand him, hating herself even more for what she will later come to call "the manacles of sexuality."

Does her story differ in any way from the classic heartbreak of first love?

She doesn't think so. She only knows that the flesh cannot bear certain things—metallic rides at a third-rate carnival, aluminum cans, tin cookie cut-

ters, the heavy taste of brass in your mouth as you circle the merry-go-round, assuming you will get the ring.

She bounces along on the truck and tells herself, the vital litany, that something is forever false about these worldly elements.

XII

Once again the truck pulls out of the shallow river and clambers to a halt. Time for lunch already? The heat is as thick as another person, or perhaps Carla is confusing the heat with Joachim's closeness, huge and dense beside her.

And once again the silence is a cruel shock. After a moment the hum of the sandy canyon floor and the energy of the looming red cliffs wells up, but it is something you wait patiently to hear.

It is difficult to tell how far they have traveled. Since Canyon de Chelly is long and windy and thin, you don't keep going down and down and down as you might in, say, the Grand Canyon. You cannot measure your progress by your depth. The cliffs are higher now, so you know you have descended, but at some point the truck seems to have leveled off.

Carla cannot imagine how you would find your way out if there were no river. Thinking of that cool energy, she swiftly extricates herself from the metal and all its difficulties and steps out of the vehicle, creating distance between herself and whatever pursues her.

"You've got a friend," Lucy sings, catching up with her and making no attempt to control her mirth.

"Is this lunchtime?"

"Hardly." They stand and watch the water, its mirrorlike ripples and its rosy cliff reflections. "In fact, it isn't even ten."

This information is truly distressing. Perhaps they have entered a time warp, or the heat has stopped the clocks. "But we've been riding for hours!"

"That's right. Three hours. We're almost to Mummy Cave. Then we go back out Del Muerte and all the way down the main canyon." Lucy counts on her fingers in an amusing imitation of Johnson. "One canyon. Two canyons."

"Then why did we stop?"

"Ask your boyfriend."

Lucy and Carla half-turn and watch the Germans amble off in a movie-making way. Johnson has remained seated in the cab of the truck, and his body language seems to indicate that he'd like everybody dead. But the *artistes* don't care. Dieter walks over to the cliff face. There is an overhanging projection with a cave hollowed underneath, like a mother bird's wing protecting her invisible baby. More pictographs, of course. And, above them, the pearly pueblos hover. They are everywhere now; it is shocking to think how many people could inhabit them, how many cities these people could fill.

"You have to admit he's handsome," Carla says defensively.

They both glance at the retreating figure of Joachim, his firm rear end

and the broad triangle of his shoulders.

"Not really my type," says Lucy. "But I bet he's good in bed."

An image of Michael arranges itself in Carla's mind: his clean clothes, his scrubbed body, his sensitivity to the problems of women. His basic decency.

"Sex is supposed to be dirty," Lucy adds.

Joachim is not the cleanest guy in the world. His hair is lank and a slight sheen of oil gleams on his forearms. His very muscular forearms.

Lucy chuckles. "Dieter is more your type."

The idea of touching Dieter is a sensory shut-down, a figurative cold shower. Rubber lips, probably.

At least Michael doesn't have rubber lips.

But this is all pointless speculation! What they have come here to do has nothing to do with any of this—she has certainly allowed herself to become distracted. Besides, Joachim is more terrifying than attractive. And he already has a girlfriend.

And, to be perfectly honest, she has learned to avoid any sort of adventure; perhaps she is no longer even capable of such a thing. Each one of her days is an ordeal all in itself—painful, fraught with risk and excitement. What more could she need? You never know what sort of odd energy might be hovering near you, what kind of misery might be headed your way. It is an adventure to be different, to be strange; what you long for is the ordinary.

And this trip is certainly not ordinary.

Once again she stares in the distance toward Joachim. He has followed Dieter to the little cave. Cartoon ripples of heat rise from the desert floor between them. The faint breeze smells of sage and verbena.

In a few more hours she will have rid herself of the necklace. She and Lucy will drive to Phoenix, where they can sip martinis and swim in the warm pool under moonlight—except that Carla could never swim in a public pool! Anyway, they will be safe in the cradling embrace of a calmer, more predictable world.

Where nothing is ever quite worth it.

"Let's go see what those guys are up to." Lucy's face is trenched into enthusiastic lines, and she sets off at a brisk pace.

And Carla shuffles along behind, dragging her tennis shoes in the dust, a silly kid who wants to be forced to go somewhere, like the high school dance that everyone made fun of but went to anyway, as if you had to, and you complained all evening, even though no one was making you stay.

Childishly, she heaves a great sigh so Lucy will know that this isn't what she feels like doing. Who cares about those silly Germans? That remark about being good in bed was all wrong.

Now the whole crew is standing under the winglike projection, with Wolfgang wedged under so far that only his running shoes are visible. Dieter has a measuring tape and is pacing and marking and tsk-tsking in a manner

The Other Canyon

both serious and predictable. Solange is jotting down something on her clipboard, probably whatever Dieter is muttering, but every few seconds she glances at Joachim as if he were the clock and time were important. Nonchalantly, he stands to one side, contemplative, artistic, smoking a cigarette.

Lucy and Carla stop about twenty feet away, just under the rim of the shadow, and this is somewhat unpleasant. The sand is damper here, more vibrationally emphatic, and the air is chilly, as if it wafts up from the icy heart of the planet.

Solange shivers and rubs her luminescent white arms, as if their arrival has chilled her. Her hair, away from the sun, is the color of dried blood.

"Do you think they're actually doing anything?" Lucy whispers.

Probably they are. This could even be a piece of performance art. On the other hand, Wolfgang has disappeared beneath the overhang while all of his equipment remains in a pile near Dieter. What can he be doing without a camera?

Carla shrugs, feigning indifference. Joachim seems oblivious to her presence. "It's too cold under here. Let's go back."

They step back into the dazzling sunlight and are struck once more with the wild beauty of the canyon—the warm fragrant air, the bright cliffs, the exhilarating isolation. But as they approach the truck, adjusting once again to the heat and the dust, they can see that Johnson is angry. He has climbed out of the cab and stands watching their approach, arms akimbo.

"The truck is leaving," Johnson announces, once they are within earshot. His sunglasses effectively mask his eyes, but you can more or less imagine his concealed expression.

"Sorry to keep you waiting." Carla smiles, the dutiful child.

Johnson grunts and gestures toward the film crew. The women look back at where they have just been to see if, by some fluke, the work is completed. But no. Nothing has changed. The Germans are deeply engrossed in their mysterious processes.

"I'll go get them," Lucy volunteers eventually, to break the tension. She scampers off gracefully, a filly released from her corral.

"Handsome behind," Johnson observes, so matter-of-fact that it's difficult to take offense. Besides, Carla has been making the same sorts of observations about Joachim.

Carla and the guide remain there a moment in faux male-bonding. But then she becomes aware of the energy emanating from his necklace, so solemn and distinct. "Where did the silver for this come from?" she asks, pointing with her finger.

"There's no silver in the canyon," Johnson says sharply, terminating their brief moment of camaraderie. "Nothing of value in this entire canyon," he continues in a gentler tone, attempting to mitigate the vehemence of his

initial response.

"Well, I'm sure." Although intended to soothe, this remark lingers in the air sarcastically.

Johnson openly glares.

You just can't win around here, she thinks, stung. Show a little interest, and you're the ugly capitalist, exploitation up your sleeve. Agree to their secrets, and you are a fool—a white fool who cannot detect what the air and all its elements are telling you.

Lucy does not immediately return. Standing at a stony distance apart, Carla and Johnson observe the pantomime of information being conveyed. Lucy gestures to Dieter, who shrugs and turns away to gesture at Joachim, who does not appear to move at all; perhaps he responds in subtle code signals, like a VIP at an auction.

Dieter turns back to Lucy, making dismissal motions. Lucy points toward the truck. The mysterious work continues. Clearly, no one is about to stop working; clearly, no one is much impressed.

So, after about five minutes, when it is evident that she has made no progress, Lucy comes shuffling back, looking guilty and responsible. "They need a few more minutes," she explains.

"The truck leaves now." Johnson turns on his heel and heads for the cab. He acts as if this is somehow their fault—are Lucy and Carla responsible for the Germans, as if they had dreamed them up?

"What do we do now?" Carla asks. The canyon seems larger now, wider, and the walls higher. The air grows increasingly intense in the heat, and the water thinner, more trickle than river.

They regard the truck, which is vibrating, motor running, ten feet away. Climbing aboard that truck again seems profoundly disturbing, especially with Johnson's fresh fury flashing through the metallic body. So then they regard the film crew, whose behavior remains obscure. The heat shimmers across that long stretch of air, the great orange-pink cliffs rising up and waiting. Right on cue, a flock of birds soars above, floating without any detectable movement of their wings, no effort required. These birds are at home here, and the women are not. Whatever it is that Johnson has allowed them is the only thing that allows them to be here.

In tacit agreement, they climb aboard the truck. It skids off in a flourish of dust, motor crunching and grinding like a death machine, and probably not one of the film crew has even bothered to notice.

Immediately, Carla misses Joachim. Where he sat only half an hour before is now filled with anti-Joachim space, as if his other, equally powerful non-self is blotting out his presence. In this odd way, he now exists for her as a double-entity, a mystery box.

❀ ❀ ❀

She rides in a car, long and white, on a rolling drive parallel to the ocean. In fact, the road rises and falls like the swelling sea, but she is not paying much attention to that. What she notices the most are the trees, the grand eucalypti which are both as tall as redwoods and as close as the arms of your mother: the great "somehow" of dreams. And the houses—on both sides of the road, old California houses of the thirties sit as stately and adorned as movie stars. Their gardens are manicured with yellow and orange and pink and lavender flowers. The car rolls from the houses at the bottom of each rise to the top of the hills, where one can glimpse the ocean of French Impressionism, the glittering blue and white of Holland. So lovely, so ideal, so charming!

And this is what the dreamer feels: I am here now, I am in this beautiful place, this place is the most beautiful place there is, here and now.

I am safe.

And then, at some point, the houses begin to recur. There are only a few houses after all, even though they seem to continue forever—it is an infinity loop, a treadmill. Not very many people can fit here, only the few, there is so little room, and only the illusion of space...

When Carla awakens, only minutes have passed. The truck has stopped. First she shakes the dream, somewhat reluctantly, and then she is glad to leave the dream—they have returned to the production scene beneath the overhanging rock. Joachim and Solange are still standing to one side, and neither Wolfgang nor Dieter is visible. The first two are peering under the crevice, though, so it's pretty obvious where the others, and probably the absent equipment, are located.

No one deigns to acknowledge the reappearing truck.

Johnson hops out of the cab, a mere ten feet away from the overhang. "Fuck this!" he shouts.

Joachim slowly looks up, but he stares at Carla and not at Johnson. Her side of the truck faces him, so close, as if she had been brought there on a platter. The sun glints off his heavy brass ring.

Never breaking eye contact, he climbs into the truck like an automaton. And when he is next to her, he takes her hand, looking more deeply into her eyes. "*Geben Sie es mir,*" he whispers.

A strange, overwhelming joy as their fingers lock, the zap of the real connection. For all her thoughts of remaining separate and distinct, she retains nothing now, she is whitewashed, she is hypnotized, under a spell, she is gone.

Solange watches sadly as the other two Germans slither out from under the rock and begin to pack up the equipment. Under Johnson's furious visage, the truck is loaded once again.

Everyone is eventually reseated and the truck, after a false start, anoth-

er stalling out in the river, lurches once more into motion.

And once again they drive back into that time that never was, his electrifying hand, the cool damp of his fingers. The deeper they travel into the canyon, the earlier the age of mankind. The canyon has assembled these cliffs around its impossible secrets, unless you dare to dagger its very heart, that irrational inward quest.

Let well enough alone. Let the walls be the walls.

XIII

Now that the connection has been made, now that the bond, whatever it may be, has been established, it is time for Carla to consider Michael.

Instead of the peculiar brass of Joachim's seal ring, her hand should be touching Michael's gold and ebony emblem: USC, Class of '84. Not to mention the fact that her hand should also be wearing its own ring, its platinum engagement ring. That very ring, which might have prevented any of these unlikely interactions, is in Mr. Powell's office at this very moment, waiting to be sized. The fact that the ring did not fit made Carla hesitant—does this imply an ill-fitting marriage, one in which the expectations must diminish?

He gave her that ring a month ago tonight.

Michael arrives at eight o'clock sharp. Carla is ready and waiting when his top-of-the-line BMW swings into a parking space in front. Unlike her car, which seems regal until you examine it closely, his car is genuinely ostentatious, perfectly buffed, the vehicle of a man who intends to make his mark upon the world.

From the cheerful puckering of his lips, you can tell that he is whistling, probably along with one of his CDs. After turning off the ignition, he fools with his hair, fluffing it out over his ears and glancing into the rearview mirror. His hair, worn slightly longer than that of most attorneys, is his major vanity. He claims he has two distinct personas: Hair In and Hair Out. Hair In, in which his lush mane is slicked back, sort of Pat Rileylike, represents his professional world, his lawyer mask. Hair Out is allegedly relaxed and surfer-loose. Tonight, for Hair Out, he is not wearing his usual flat-front khakis and designer tee shirts but rather a formal version of the same effect, complete with linen jacket and polished loafers.

Peeking through the curtain, Carla watches him walk toward the door, tall and heavy-set—he could have been a football player except he was too smart—and he is no longer whistling. She savors this expression since she knows that the instant she opens the door, the face she sees now will disappear. His visage will spring into cheerful contours, hail-fellow-well-met, the face that Michael imagines Carla really loves. In fact, it is the expression before the metamorphosis that interests her.

In repose, and only off-guard, he is an entirely other person, one that he has excised from either of his controlled self-images. This other person has an air of isolation: an abandoned child watching his parents pull away from the orphanage, or the loyal comrade beholding his closest buddy smithereened by a grenade. Sharp grooves on either side of his cheeks seem to point toward his eyes, which are holes, really—holes that you look through to see this intriguing, miserable subconscious roiling beneath.

His shiny black hair frames this sad face a la Prince Valiant, a style only obvious in the Hair Out manifestation. His tall, somewhat hairy body has just enough fat to make him always huggable, and his hands and feet are long and pale.

"Hel-lo!" he calls out gaily as soon as she opens the door. All trace of sadness has disappeared as completely as a box of Godiva chocolates. "That's a cute little outfit you're wearing." He's one of those men who always thinks that whatever women wear, it is an outfit. In fact, Carla is wearing a cream-colored crepe de chine dress, very elegant, but also something he has seen at least four times previously.

Magically, Michael produces a small florist's box. Inside is a gardenia on a woven ribbon bracelet.

Touched, Carla stands on her tip-toes, awkward in her strappy sandals. She kisses his cheek, which is freshly shaven but already scratchy from his heavy beard. Woodsy and elegant: Aramis.

"Reservations are for eight-thirty. Let's go!" he urges in his bracing, camp counselor voice. He waits just inside the door while Carla gathers her purse and jacket. Even though they have been together for almost two years, he continues to enjoy preserving that formal, official date elegance. And she likes that, too.

In fact, this is one of their major bonds: that desire to be viewed from the outside (although who does the viewing is immaterial) as attractive, stylishly correct, wholly enviable. They can imagine themselves photographed for magazines, the couple climbing out of the luxury car or sipping the perfect beverage in the ideal vacation spot. Sometimes they imagine that they are once again in high school, only this time, things are perfect. This time Michael is not in a dull, painful military academy, shuttered away from all girls his age, and this time Carla does not waste three years of her life mooning over André, who does not understand why anyone would want to go to the Senior Prom.

"Ready," Carla announces, and they glide out into the flowery twilight, which would, in truth, make an excellent background for a liquor ad. She struggles with herself not to glance for slugs or snails. The chrysanthemums and alyssum are so much more subtle than the human beings, who, although they imagine they are impersonating flowers, smell so hopelessly expensive.

"How many USC students does it take to screw in a light bulb?" Michael queries as he opens the passenger car door.

Carla sighs. The downside of Romantic is corny. But as she slides into the BMW, the metal says, familiarly: *I am lonely. Please love me.* The smooth leather seats have always smelled brand-new.

Michael climbs in the driver's side and starts the car. Even his keys calm her energy field, as if something in him absorbs what is scary out of the

ether. "Eighteen," he announces, as they pull away from the curb; she never attempts to answer his jokes. "One to put in the light bulb and seventeen to demand course credit."

She is not expected to laugh, either.

They are passing John Wayne's estranged widow's former dress shop. The awnings, the begonias, and the lobelia all say, *Aren't we adorable?*

"Got a good laugh at the alumni meeting last night."

"That must have been exciting."

"Feel like lobster?" he asks, after a short silence.

All the houses on Bayview are blue and gray in the pearly light.

Sailboats like children's toys glide on the sharp midnight water. Roofs and docks twinkle as if posed on diplomats' Christmas trees.

"Sounds delicious." Carla presses her nose to the gardenia and inhales the fragrance of blissful vacations in Tahiti. Kindness is in order, not bitchiness.

Who else would ever bring her a flower for a date?

And, besides, Michael helps her work on her full-time project: being normal. They want to be of the masses, only smarter and richer. Their dating motif is similar to the theme of the old Bertolucci film, "The Conformist." The people who really wanted to be Fascists or Nazis were the handicapped, the broken, the maimed—the ones who, ordinarily, might never be chosen for any group.

Speaking of Nazis and Fascists, the BMW pulls up in front of the Balboa Yacht Club. Several men in white shoes and navy blazers are waiting for the surfer-boy valets to bring them their status vehicles. They cup their hands against the brisk salt wind so that they can light their cigarettes. Wives wait in head-to-toe Gucci, Chanel, or Versace. Their jewelry is very large and very gold.

"Land of the eternal John Birchers." Michael's voice is cheerful as he turns off the ignition, but he stutters slightly, which he tends to do when he is being hypocritical.

Next to his secret face of misery, Carla loves his stutter the most. How could you resist a stutterer who decides to become an attorney? Although he has never related any such experience, she can easily imagine him poised in front of an embarrassed judge and jury, everyone squirming in sympathetic agony as he struggles to express his final significant point. His tongue hopelessly entangled, his face glowing with the strain. Possibly this explains why he is so successful?

But they have never discussed it.

A blond adolescent with his hair tied back in a ponytail saunters over to park the BMW. His tennis shorts and shirt are casually expensive. No one would ever believe that he really needs the money; he probably receives very large tips for not producing guilt. Like slipping your nephew a little pocket cash.

Patricia Geary 81

Michael and Carla stroll inside. Red and white and blue nautical furniture is clustered in chat groups with the predictable types lounging and chatting. Fruity margaritas for the ladies and Scotch or vodka for the gentlemen.

Michael doesn't like to drink, and he won't exactly say why. Perhaps he is afraid the pain will emerge, but more likely the explanation is more banal: he prefers, as a child would, the sweet taste of soda pop. Consequently, they do not linger in the bar area but sit, instead, at the table where the maitre d' places them—one of the best tables, with its postcard view of the bay.

Reflexively, Carla palms the silver salt shaker, reassured that in this place, there will never be any jolt from metallic contact. The atmosphere and the people are simply too innocuous. Smooth white linen tablecloth, heavy silver sugar dish filled with actual sugar cubes and accompanied by a pair of actual sugar tongs: here, there are no real secrets of any consequence.

The purple night darkens and darkens, a towel placed over a puddle of spilled ink.

Michael is slouching back, his large frame wanting to relax but not quite being able to.

"Let me hold your ring for a minute," Carla asks. This is one of their rituals.

Smiling, but this smile is the falsely jolly one that does not sit so well against his mournful eyes and sad jaw, he hands it over. "That's valuable property," he points out, back in his preppy persona. "If anyone here went to UCLA, I bet I could turn a nice little profit."

Carla cradles the ring in her palm. In this piece, she can detect the double buzz of his personality. On the outside, all is normal; from the inner core of the circle—The Taoist Negation, the part where nothing is—comes the Other. Its cry is deep and plaintive, a child wanting to be born through her. Is she willing to take on this burden? She positions the ring speculatively on her thumb and twirls the gold and ebony around and around, a kind of magic top. Perhaps it will predict her future.

"When you get tired of playing with that ring, maybe you'd like to try this on." With such a show of calculated cool that Carla is almost fooled, Michael tosses a small blue Tiffany box onto the center of the table.

For a moment, they both sit and stare in surprise. Do they imagine that it will open and rise up like an enchanted cobra?

Her hand reaches forward and then stops. For all the good reasons in the world, she is afraid.

Carla's eyes dart up to Michael's. And this time, for once, he cannot hide his true face, his concern, his fear.

And this is the hardest part: what does he fear more—acceptance or rejection? Does he actually love her, or does she actually love him? Next to his precious law degree, his bachelor image has always been his proudest possession. Why would he want to give this up? And why now?

The Other Canyon

As her hand continues to hesitate, Carla tastes the minty essence of freedom, and how valuable it is to her. As usual, you cannot know which, of all the possible paths available to you, is the one that will set you free.

Carla recalls the *Tao Te Ching*, which was also one of André's passions:

> Thirty spokes
> Share one hub.
> Adapt the nothing therein to the purpose at hand,
> And you will have the use of the cart.
> Knead clay in order to make a vessel.
> Adapt the nothing therein to the purpose at hand,
> And you will have the use of the vessel.
> Cut out doors and windows in order to make a room.
> Adapt the nothing therein to the purpose at hand,
> And you will have the use of the room.
> Thus what we gain is Something,
> Yet it is by virtue of Nothing
> That this can be put to use.

And what can any of this mean to her now? How can she know her path? How can she understand the endless somethings and nothings that slip through her hands each day, platinum rosary beads, and what are the prayers to which these beads are attached?

The shape, the form of what she and Michael are together, might be the emptiness that creates Something. Or, it might be, as she suspects in her deepest heart of fear, genuine nothingness.

And yet. And yet she has invested over two years into preserving the form. He is a good man, a kind man, a patient man. And, it would seem, according to the Tao, the form is finally what receives all the attention.

The box disintegrates in her hands, a once-blooming flower. Inside is a pair of perfectly matched diamond earrings, crystal and clean, safe and pure. Tears from the perfect Muse.

Tremendous relief.

And a perverse pang of disappointment.

"Oh, they're beautiful," Carla gushes, as the waiter presents their shrimp cocktails. "Thank you so much! But what's the occasion?"

"Oh," says Michael, eyes averted, face starting to go crimson as he temporarily stalls out with his stutter. "We-we're celebrating this ma-marriage proposal."

And he places another Tiffany's box on the table.

Checkmate.

Nervously, Carla fingers the heavy sterling butter knife, its round han-

dle as smooth as a professional butler.

She stares at Michael until he is forced to stare back. And it is that look—wordless, pleading, head tilted slightly and eyebrows straight and sad—that finishes her off. How could she ever have the heart to turn him down? And what makes her think she will ever have a better offer? Now she is a sitting duck. A cooked goose.

The platinum band in the box encircles another diamond, this one large and resplendent.

The water in the bay through the picture window appears as black as the dreams of your ancestors. The lights from the late returning sailboats bob determinedly across the darkness. The dining room has also grown dimmer, its white-clothed tables isolated as if by spotlights, and the vases of fresh flowers cast ghostly shadows. The candles both beckon and repel.

Michael's eyes are mysterious now, unreadable. Maybe some sort of pale light shines down from the deep.

Maybe.

And, of course, the ring is too loose on Carla's finger. The folds of the net are gathering, but they have not yet drawn tightly around her. Closing her eyes, the ring resting in the palm of her hand, she sees it all:

Tiny gardens of pink, yellow, and blue flowers.

Lovely lobster dinners like the one the waiter is about to place in front of her.

Silks soft as skin. Woven linens. Cashmere.

Or a sunken bathtub. A view of the ocean from your own balcony. Peace and quiet.

Real privacy.

The elegant language of pathos in Michael's rough cheek.

XIV

But that ring has been left behind. And so have her choices. Now there is now.

Carla reluctantly removes her hand from Joachim's.

And Joachim, half-slumbering like everyone else in the rocking rumble of the truck, bright sun searing down on them, does not seem to notice. The motion of the ride slowly jostles them apart. These pink cliffs seem to have surrounded them forever—does the world outside of this one still remain?

From its nest inside the backpack, the necklace hums happily.

Lucy's long eyelashes droop down over her tanned cheeks. She dozes with her lips slightly open, bright teeth gleaming like bones. Wolfgang slouches on the floor, beret shading his eyes; he seems to be dreaming, and perhaps of the other life. Dieter is crisp and upright, even in his snoozing, and Solange has pivoted away from them all, her face nuzzled down into the basket of her forearms.

And Joachim is as unreachable as a marble statue. The little green glasses cover his eyes like half-dollars over the lids of the dead.

Is there an enchantment that seeps from these grandiloquent walls, like the poppy field in *The Wizard of Oz*?

Almost, if she softens her gaze, does not allow her eyes truly to focus, she sees ghostly shadows moving in the noonday sun, shadows hovering in the doorways of the myriad of abandoned pueblos that the truck is forever passing. The transparent spirits, or so it appears, sit in the shadows of the cottonwoods and weave their baskets, grind their corn. If they see the truck passing by, they do not let on.

In this way, they maintain power over both worlds.

When Carla opens her eyes wider and attempts to focus, she sees nothing much at all—the spirits are just odd angles of light, sudden shafts through the doorways. She is a scientist explaining away the UFO.

And the pain distracts her. Her back hurts where the seat jostles it, and her rear end is saddle sore. Her hands and feet tingle, as if the blood were trying to escape. And her white hair has gone brittle as cornstalks against the sunburned skin.

Woe is me, Carla thinks.

Joachim stirs and brings his heavy hand to her knee, the brass ring that promises all those things she has structured her world to avoid. A little shiver in her pelvis—excitement or fear?

Once again the truck pulls up out of the river and grinds to a halt. As if the spell has been temporarily lifted, the passengers come back to life, fluttering their eyelids like leaves in the wind.

This time the Germans move quickly, clambering off the truck right away, no doubt not willing to risk a moment of precious time. Joachim gives Carla's thigh a little squeeze, as if to say, *keep your motor running, honey, I'll be back.*

"Hubba hubba," says Lucy. "Hot Mama!"

"Give me a break," Carla mutters, hurrying off the truck as well, yet she can't keep the smile from her lips nor the flush from her face.

Surprisingly, the ground feels good, more welcoming than before. Maybe all this energy is insinuating itself into her pores, her blood, the air she breathes. Tennis shoes planted firmly on the sandy canyon bottom, she can't deny the intensity of the energy—it is zappingly there, and very necklacelike—and yet it is not draining her. Even though the ride is taking a physical toll on her body, she is oddly refreshed. In fact, as the breeze wafts sweet verbena through the swift orange canyon, Carla wonders if she has ever in her life felt so entirely alive.

"Are you in love?" Lucy asks, shading her eyes and scanning the looming wall that the truck is adjacent to. "Want some water?"

"Thanks." The water from the plastic bottle, even though it was in the backpack and therefore has been resting in the nest of the wild animal, is soothing and calming.

"Or perhaps it is merely lust."

"I think the necklace has changed. I'm not afraid of it anymore."

Lucy's forehead squiggles into lines of concern. "I'm afraid it's love!"

Carla sips more water. The sun is very strong. "Are we as far into the canyon as we go? Is this the turning point?"

Lucy lights a cigarette and sips some water from the bottle. The sky is a misty, opalescent blue: frosted glass, the luminous pastels of Georgia O'Keeffe. Her vision was perhaps not unique: she was merely painting what was there. "I think we're at the mouth of Twin Trail Canyon. That's just a few miles from Mummy Cave."

"And that's where we turn around?"

"That's the end of the line."

The Germans are bickering in the distance, banging their equipment and trudging downstream. "I meant what I said about the necklace."

"And I meant what I said about love."

"What's at Mummy Cave, exactly?"

Lucy squats down on her haunches and draws a little picture in the sand with her index finger. "Mummy Cave, here"—a long squiggle—"is only two-thirds of the way down Del Muerte. We don't even go down as far as Massacre Cave."

Massacre Cave. Creepy.

"The rest of the canyon goes on like this. And then the whole other canyon is way down here." The two fluctuating worms intersect, creating a

wide angle.

"What's in between these two canyons? All this space in here?" Carla traces a line with her forefinger. Funny how she doesn't seem to need gloves anymore.

"I don't know. The maps are all sort of sketchy. No cartographers are allowed down here unless they get the okay from the Navajo Nation."

Carla stares at the space in between the canyons, at the unknown. *Thus what we gain is Something, yet it is by the virtue of Nothing that this can be put to use.*

She shakes her head, her eyes going blurry. Is there Something there before her? All she knows for sure is the Nothing part.

"What is it?" Lucy's voice is rich with concern.

"Nothing." Carla's voice is firm.

"Well... okay." Lucy stands up and brushes herself off. Those lederhosen must really feel like lead in the heat. "Let's walk over by the shade of the cliffs and I'll let you in on what Lover Boy and his Band of Merry Cameramen are up to."

Carla is curious about Lucy's source, but she decides to remain patient. As they stroll over toward the nearest pueblo, it hovers above them Mt. Olympuslike, a pearly dollhouse: intact, adorable, unattainable. They crane their necks upward, momentarily disinterested in speech. In the heavy heat of the late morning, the ancient home is an apparition, magically undulating, shimmering in the heat as if the air were water and it were reflection.

If you don't look too closely, shadows seem to move behind the solid square windows, their flat dark absences, where there might be glass, making a shape in the space where there is no barrier from the other world—as if some evanescent presence were waiting in there, a mere fraction of an inch out of sight. The urge to spring up and into the dwelling is almost overwhelming: it seems so close in its tinyness, the moon you can reach out and pluck like an orange from your tree. Surely one wishful dream-leap could send you soaring?

"Ever heard of the term *ostranenie*?" Lucy asks.

"No." Seems like a weird time for etymology.

"It's a term used in criticism. And it means 'making the familiar strange.' It refers to a literary device, one Dostoevsky, among others, used: a writer describes an ordinary experience in such a way that at first you don't recognize what's going on."

"Uh huh."

"Look, I'm just trying to explain your precious German to you!"

Now she gets Carla's attention. Leaning away from the pueblo, Carla fearlessly positions her back against the short iron railing that protects the site so that she can focus her attention more closely on what her friend is telling her. The proximity of the cliffs—energy that manifests like a string of fresh

flower bouquets—is pulling her away, into the ether, more powerfully than mere metal.

Lucy also turns away from the pueblo. For a moment they stare at the specks which are the retreating forms of the film crew—they have moved pretty far pretty fast. Johnson, of course, remains by the truck, a couple hundred feet from where the women are standing.

"Anyway," Lucy continues, "your boy is apparently a real innovator in the European cinema."

Irrationally, Carla's heart expands in pride. "But why film this canyon?" she asks after a moment's reflection. "This isn't the familiar. This is already the strange."

"Well, what he does is a kind of reverse-*ostranenie*, as far as I could tell from what Dieter was saying. Of course, you were too busy cozying up to pay attention."

Carla's blush is probably invisible beneath her sunburn. "But I still don't—"

"He makes the strange familiar."

"Oh!" Right on cue, goose bumps skitter up and down her arms, as if this were the greatest idea since sliced bread.

"The way Dieter talks, Joachim is the only one to do this. But, really, take the New German Cinema of the last thirty years: Fassbinder, Wenders, and, worst of all, Herzog. They all carry on about the grotesque!"

"But, Lucy, 'strange' doesn't have to be grotesque! In fact, it doesn't even have to be weird..." Closing her eyes for a moment to block out where she is—and talk about *strange*, to be having this conversation in this place!— Carla ponders the artistic ramifications. The reasons for making an ordinary something into a strange something seem fairly clear: you make people really notice what they are used to looking at, and suddenly they see what is familiar in a whole new light. This principle functions on a simple level when you move around the furniture in your house, for instance. Once again you really see the thing you have been taking for granted.

However, if you take what is unfamiliar, and you weave it into the fabric of your daily life... you take it to lunch with you... a bunch of cool, sweet grapes, smooth as apple jade, pale orbs frosted with powdered sugar. And some lemonade. Cream cheese sandwiches on date nut bread. Or cucumber and watercress on crustless, buttered bread. Yes! High tea with all the trimmings, scones and clotted cream, exactly what kept the British "sane" in India—

"And so?" Lucy queries, impassive, the sphinx not anticipating that a mere mortal could answer the riddle.

Carla opens her eyes. The Germans have stopped in the middle of a wash off in the distance, sandpipers in a trite seascape. "I'm sure it's all very deep."

"It is. Don't be so snotty."

"Basically—" Carla begins, not quite sure what her point is, and then she notices what her eyes have focused on. Below the pueblo and to one side, maybe only thirty feet away, is a whole array of swirling pictographs. The hump-backed flute player. Spiders and hands. Geometric shapes that resemble a perfect kind of language. The images flow in like a river around the corner of the cliff, past where she can see. "There!" she pronounces, triumphant, as if this had been her point all along. "Here's the strange entering our lives even as we stand here. And it's lovely and mysterious. Not at all grotesque."

Lucy squints up at the mellifluous shapes. "What, those rock drawings? They aren't the least bit mysterious. If we could read them, they probably say something like, 'Don't dump your trash here' or 'Corn for sale up ahead. Watch out for conquistadors.'"

"Oh, come on! You don't believe that? Look how elegant they are."

The sun is gentle in the shade, and the sweet smell of the canyon seems to bloom before their eyes.

"Maybe if we could understand them, they'd tell us religious rituals. Or special secrets that—"

"Special secrets that would *what*?" Lucy demands.

Carla stares at her friend in surprise. There is anger here, some upwelling of hostility, which is not really anger directed personally toward Carla but rather toward some system, some suspicious construct of beliefs. And sometimes it's a surprise to stumble over these hidden obstacles. "Don't you think this canyon is holy?"

Together they scan the panorama. The sky is blue and still as a rock. The sun endures. The immortality in the shape and attitude of the cliffs, it seems, would humble anyone. In fact, such perfect grandeur is almost humiliating—you'd think it would be impossible to make art here, to take yourself and your petty ego at all seriously.

"No."

Now Carla is a little exasperated. "But you're the one who just told me not to be snotty with that 'unfamiliar' stuff! I mean, this is deep!" She spreads her arms, and her fingers, without their gloves, tingle. Surely Lucy must feel all this?

"No, it isn't." Anger has furrowed its trenches in her forehead. "This is just a place, maybe more beautiful and more remote than most places, but it's nature, pure and simple. It only seems mysterious to you because you never go anywhere. Anything 'holy' you can find just as easily in Newport Beach."

Well, of course, that's true. Or is it? And it isn't exactly the point… or is it? Impulsively, Carla removes her shoes and tests the soil with her toes—there is a special power, she can practically taste it, in this particular spot. Its energy snakes up through the sand and jolts her into a new place. Or at least she has never before felt this power. But then it's also true that she has sel-

dom left California. In that way, she has little experience with the raw stuff of the earth.

"This place feels special and different to me," she winds up lamely.

Lucy looks regretful now, her mouth an inverted U. "I'm sorry for snapping. I think the heat is getting to me."

"Do you want some water? I'll go get it."

"That's okay, I'll go. I have to pee anyway."

Her footsteps crunch away in the sand, and Carla remains by the pictographs, thinking about how the unfamiliar becomes the familiar. In fact, she is beginning to think of the canyon as ordinary rather than extraordinary—not that she no longer finds it spectacular and unlike any other place, but rather that there is something about it which feels as if it has always been in her blood. If she isn't careful, will she somehow always believe that she is here?

The soil feels delicious and golden between her toes. Carefully, she approaches the pictographs. There are "men" with inverted triangles for bodies, their arms rubbery and looped. Men with ducks for heads, ducks larger than the bodies that support them. Little boats with crosses. Goats with arrows in their sides, looking like bullfighters have had their way with them. Two animals—guinea pigs?—paying homage to what resembles a giant corn dog. Huge hands, outlined as if from real life. Two-headed bodies. Spooky shapes with lightning zapping out of their appendages. Pregnant women with—

Suddenly Carla becomes aware that she has drifted around the corner of the cliff. And there is a peculiar vibration snapping its filaments through the ground. Instinctively, Carla approaches a small bush and brushes back its spiky tendrils. There, behind the bush and between two hovering ledges of cliff, is a little path. The walkway shimmers in the pearly noonday sun; oddly, it looks as if it has been used recently and frequently. Without any thoughts whatsoever, she eases herself around the bush—

"CARLA!" Lucy's shout is imperative.

Carla comes to her senses, and then, weirdly disappointed, retraces her steps around the cliff and back past the pictographs. Over by Johnson and the truck, her friend is beckoning her.

Reluctantly, barefoot, she returns to them. She cannot shake a sense of loss, as if she has been denied something extraordinary. She tells herself that what she saw was probably just a goat path. No big loss.

But the mind can justify all it likes. The heart knows what it feels.

As soon as Carla is within range, Johnson climbs into the cab and starts the truck. Are they once more going through the charade of abandoning the other passengers? Perhaps not, as the engine makes a hideous sound, like a cat caught in a player piano. Then it dies. Then the cat noise again. Then total silence.

The sand is extremely hot. Carla drops her socks onto the ground and

The Other Canyon

stands on them.

"Well?" Lucy asks, her face alight with excitement.

"Well, what?"

"The truck broke down! This is the first time he's even gotten it started."

"So he's fixing it. Now he'll probably get it running."

Carla's remarks, meant to alleviate anxiety, seem to disappoint Lucy. She wilts slightly. But then she brightens again. "He doesn't know much about engines, it turns out. He thinks he might have to hike in a few miles, to one of the houses down there, and see if he can bring someone back."

"What houses?" Carla wonders if these are the people who use her path.

"Some of the Navajo have farms up around this end. No telephones or anything, but the rangers come along from time to time. He's thinking he could leave a message for the rangers, or maybe somebody knows something about trucks. Maybe somebody might have the parts he needs, like that." Lucy's eyes trail away, as if she is reading something in the air.

Something about the details makes Carla suspicious. "Are you going with him?" Although the idea should frighten her, it does not—instead she feels an impalpable excitement.

"Well…"

Johnson hops out of the cab and stalks over. "Let's go." There's a strange familiarity between him and Lucy. "Three or four hours," he tells Carla. "Lunch and water in the truck. You tell the Krauts."

The three of them stare down the sandy wash toward the spot where the crew is doggedly filming.

Johnson, without another word, sets off at a steady lope.

Lucy gives Carla a worried look. "You'll be okay, won't you? I really want to take a look at these people who live down here. I mean…"
She hesitates. "I put the necklace under the seat of the truck. You don't have to wait for me if you want to go ahead—"

Carla smiles. "I'll be fine." And she will. Suddenly the air feels sweeter and cleaner, and she'll have all afternoon to explore, to rest, whatever. "I don't know when I've ever felt this good."

Lucy jogs after Johnson. "That's the part that worries me," she calls over her shoulder.

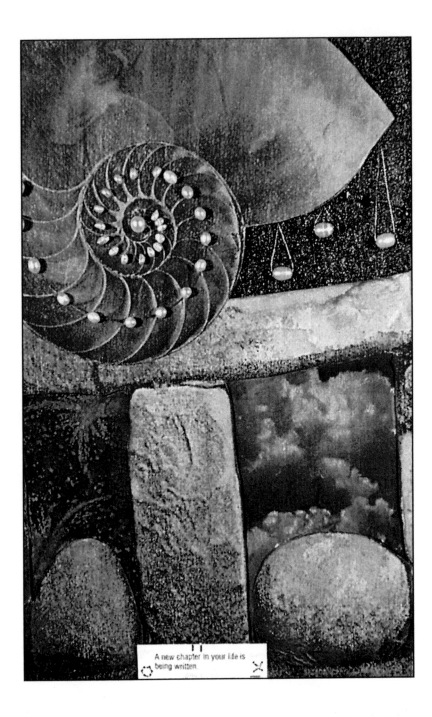

A new chapter in your life is being written.

XV

They are gone.

And now the canyon is hers. Power swells up from the rocky floor and tinglingly zaps out her fingertips.

> The way that can be spoken of
> Is not the constant way;
> The name that can be named
> Is not the constant name.
> The nameless was the beginning of heaven and earth;
> The named was the mother of myriad creatures.
> Hence always rid yourself of desires
> in order to observe its secrets;
> But always allow yourself to have desires
> in order to observe its manifestations.
> These two are the same
> But diverge in name as they issue forth.
> Being the same they are called mysteries,
> Mystery upon mystery—
> The gateway of the manifold secrets.

Lao Tzu, in all the years she has read him, has never felt so close. Now Carla is beginning to understand this business of the desires, and the secrets.

Mystery upon mystery.

With no hesitation after her body begins its initial movement, she climbs into the dead truck and retrieves the necklace from beneath the seat.

Bare-handed.

And now the poisonous snake has been tamed, domesticated; the glands of deadly toxin have been removed, provided they were ever there.

The way that can be spoken of is not the constant way.

The sun is high and perfect; the world burns to a white-hot dryness. The air is as pure as turquoise, and the shallow river is as shiny as well-polished silver. Surprisingly, Carla finds this image exquisite. As she walks cheerfully and fixedly back to the cliff face and its pictographs, back to her pearly path, the way that cannot be spoke of, only walked upon, the canyon seems to resemble one great glowing piece of fabulous jewelry. The adornment of the gods.

No escape.

And she's glad! Without really bothering to consult the brain, her feet propel her ahead. Sand hums encouragingly; we are all in this together. Air and skin are as dry and tight as two sheets of typing paper, comfy in their

bond box. No wind and no movement except the inexorable direction of her feet.

No one else makes any noise in the world, anywhere.

When Carla arrives at the pictographs, she is aware that her feet are hurting. A lot. Also, like a dope, she has not brought any water.

So, after that huge wash of enthusiasm and energy, she hesitates, after all.

The path, or no?

Now. Or not.

On the one hand, this path might not actually lead anywhere—it might just be a cut-off trail for the sheep.

On the other hand, the necklace has begun to vibrate like an enthusiastic divining rod.

"Fuck!" she shouts out, conflicted.

"Fuck?" asks a voice behind her.

When Carla turns around, Joachim is facing her. His green glasses shine like the bottoms of Coca-Cola bottles. Yet his body, standing right there, inches away, is somehow more powerful and strange than before, like some kind of frightening masculine archetype. Almost, she is more afraid than attracted, as if he were some stone-carved other being, inviolable against the sunlight.

Is it possible that his flesh has become denser and heavier than hers?

Is he a higher number in the periodic chart of the elements, a substance similar in type and yet containing more electrons in the nuclei of his atoms? Theoretically, he must resemble her—skin and blood and bones and feelings—but when she sees him there, strong and towering, all she knows is that he is Other.

Removing a small book from his back pocket, Joachim riffles through the pages.

Considering his opening remark, it does not seem likely that he will find the phrase that he needs.

Finally, he stops and sighs. Frustrated. He casts a quizzical look in Carla's direction, as if to say, sorry, this will have to do, and asks, "You vant to take valk vit me?"

They stare at each other for another moment or so. She considers Michael, and who knows whom Joachim may be considering?

And then that's it.

The others are gone, out there, not *here*, not in this odd realm where things might connect as easily as beads stringing themselves, a secret hand writing messages for only a few. True, they are only figuratively in another world, but it is also true that this connection between them is a different country. Whatever Carla and Michael had—and that was a lot: companionship, security, kindness, and caring—they never had this zapping other. This

is something you either have right away, or it never appears, some chemical acts of God, impossible that the formula can ever be complete without *this*.

Neatly, without touching his electric hands, Carla extracts the phrase book. She looks back, significantly, toward the direction where the rest of the crew must be. And then she asks him: "*Sind Sie allein hier?*" *Are you on your own?*

Carefully, they both step around the corner of the cliff, and, sure enough, there is Solange in the distance. Although she is very far away, her cobalt blue blouse, auburn hair, and luminous white arms shimmer in the knifing heat.

Joachim looks back at Carla. His face is totally blank. Her sensitivity to him is not visual; she receives no clue at all in this moment about whether he is lying or being saintly. Is his heart pure? For that matter, is hers?

Or maybe it just doesn't matter.

"*Ja*," he says, taking her hand.

Her throat catches and her feet throb against the sand. As an excuse for freeing herself, if only for the moment, she gestures downward and then puts her tennis shoes back on, without socks. Better. The necklace slides into her pants pocket.

Even now she cannot look directly at his eyes for very long. Tacitly, they return to their former position, around the cliff, near the path, concealed from the others. They are in the shadow of the rock, which is cool and promising, as if the air here issued from an altogether different world.

Carla points toward the pictographs, and Joachim peers upward.

The odor his body issues is rusty, earthily pungent. Like freshly turned dirt, his flesh is something that needs to be touched and smelled.

When she stops watching him staring at the pictographs and looks at the pictographs herself, her fingertips begin to buzz. Energy received. Almost, if she looks yet does not really focus, as if her gaze could somehow soften or melt, the duck-headed men, the hunchbacks, and the giant guinea pigs begin to move.

But no. How could that be possible?

When her eyes come back into focus, the pictures are frozen, stuffed animals that shift around a child's room during the night yet are firmly back in place when the sun rises.

Joachim continues to stare.

Once again, Carla allows her eyes to go blurry. This time, a large female shape, which seemed inconspicuous before, begins to hover and wave, her spidery arms beckoning. For one clear moment, the world goes sharp as an ax. And then, panicking, Carla looks too closely.

And there is no large female shape among the pictographs.

A gust of wind rattles the bushes, a literal breath of fresh air. In front of the entrance to the pearly path, the concealing shrubbery begins to sway,

graceful as a ballerina, her long arms outstretching.

Once again, Carla moves unhesitatingly forward and reconnects with the path. The pink clay glimmers; the trail is only about two feet wide, and seems to lead both nowhere and forever.

She follows. Behind her, he follows too.

For a quarter of an hour, they march in single file without stopping or speaking. The pink path rises upward almost immediately, and then winds higher and higher up the base of the cliff, concealed at first from anyone's view, should anyone be watching, by the bushes, and then winding behind a projecting formation of rock, hiding the passengers farther inside the very walls of the canyon. Perhaps there is a large jag in Del Muerte at this juncture because they seem to be headed for the space that lies in between the two canyons, the wide angle of repose. And then the trail begins to slope gradually downward, they are descending, and Carla hears Joachim clear his throat.

For one odd moment, she is almost surprised to be reminded that he is back there. She has been blindly progressing, one foot following the other, as if the trail were some kind of hypnotic sidewalk.

"'She valks in beauty,'" Joachim announces. And then he begins to recite:

> She valks in beauty, like the night
> > Of cloudless climes and starry skies;
> And all that's best of dark or bright
> > Meet in her aspect and her eyes;
> Thus mellowed to that tender light
> > Vhich heaven to gaudy day denies.

Somehow Lord Byron seems entirely appropriate here, even in a heavy German accent. Perhaps this is his way of transforming the strange—the poetry of life—into the familiar.

While Carla ponders, her steps hesitating, an appropriate response, a heavy arm falls across her shoulders, like the log that secures the back of the door in a pioneer's cabin. He is wedged up behind her, his brass ring burning like a flame at the base of her neck. His hand encircles her throat, and then she stops entirely, half-turned back, caught by the cliff walls, her arm, her own failure to stay in motion.

No one can see them now except the spirits inside the clay.

His skin exudes its sweet rustiness, a hint of cloves, and his lips are warm and fluid. They sweeten her lips, comforting as breakfast, the tip of his tongue opening her mouth like an agile crowbar so that her tongue is playing now, too. Tongue to tongue, lips past lips, his chest as firm and comfortable as a well-made mattress.

The Other Canyon

Kissing Joachim is like being entirely inside a tunnel of warm, pink taffy. And for a moment, she is entirely inside, but then a separate part of her, the zoom camera, whips up and out and away, a kind of astral projection, a doubling other, and watches from the outside.

The First Kiss. The happy embrace, two candles melting together in the impossible heat of the sun. The passion seems predetermined, and yet the odds are against them: they pull apart, drenched in each other's perspiration. Somehow Joachim's glasses have come off, and Carla can see in his eyes the reflection of her own earnest confusion. But she cannot tell if he merely reflects her feelings or if they are, in fact, feeling the same thing. Hands are intertwined, but unless you think carefully, you cannot tell whose hand is whose.

The words, possible or needed. The gaudy sky is all, the throb of his heavy ring is the heartbeat of a captive bird.

Carla doesn't want this; oh, how she wants this!

The very concept "Michael" seems absurd out here: a Victorian book of etiquette on a jungle safari. Coupons for McDonald's on a desert island. After a moment, they turn and continue along the trail. It slopes down now, rather steeply, almost as if breaking free. Their hands remain clasped, Carla holding hers at a slightly shoulder-challenging angle behind her back.

The necklace in her pocket, yet another captive, flexes like a jolly star.

Abruptly, the trail completes a switchback and opens out. And a vast panorama opens out before their wondering eyes—a seeming infinity of sheer orange cliffs and fertile valley. Everything here appears lusher and richer than the rest of the canyon; as Carla stands on the edge of the new world, absorbing the landscape, she detects the metallic pull of both gold and platinum.

But that's silly, isn't it? This must just be another arm of the same meandering space, and the only thing that may have changed is her, because of the kiss. Surely, this valley is nothing special—probably a farming area on the other side of Mummy Cave, or a well-known short cut to Massacre Cave.

What kind of massacre was that, so far into the canyon?

She shakes her head to rid it of that troubling question. Then, departing the trail, the man whose hand she is holding following along, she enters the actual floor of this fresh, new place.

A sparkling blue river, deeper and purer than the shallow wash in Del Muerte, flows with vitality and energy. High up the cliff sides are more of the familiar glowing pueblos, yet these seem to be more perfectly preserved than those on the other side. In fact, if you didn't know differently, you'd think these had been only recently abandoned, perhaps the very moment before you looked at them. Their empty windows watch like gods' eyes; they do not blink in the full rage of the afternoon heat.

Carla and Joachim continue their stately progression, a wedding march

of sorts down an interminable aisle. They, themselves, belong here in the canyon in the same way as the stones or the water or the shadowy memory of childhood nightmares, when the world took whirling shapes and you were too young, too ignorant, to know how to fly. Now the body is no longer bound to this earth, and yet, ironically, moves down into its very center, the sticky appendage of the heart, where even the cool water cannot cleanse. The air is as clear as sleep, and the cliffs are the cool language of the dreamer.

They keep walking and yet there is no effort, as if they were on a moving sidewalk or a conveyor belt, passing through the Platonic ideal in a well-orchestrated theme park, the ever-progressing transportation of the future. Or, they could be actually standing still while some unseen hand projects the scenery around them, the illusion of movement in the early days of cinema. Yet, it is the third possibility that seems the truest: they are on a treadmill, and the canyon is slowly closing itself around them, the walls the extended pseudopods of the sphinx. Perhaps you are being captured by aliens for dinner! Or, God is merely testing you with another act of concealment.

God or gods are watching, that's for sure. This pure connection with silence is what Carla always imagined reality could be—on her real days, when she knew that what she felt was there so absolutely that no one could ever call what she sensed fraud. This silence is also the silence of those dreams you are truly glad to awaken from, psychic pain in the black center of the night, the ink black of pre-morning, the famous darkness before the dawn.

The silence that being alive means to prepare us for, the mansion that awaits as the pueblos wait upon their elegant, structured ridges.

Maybe, Carla thinks, this is what being alive will be like when people abandon words, and use, instead, the emphasis of skin to tell their stories. The original connection of hands to explain the meanings our bodies make.

But perhaps she only imagines this because the connections her hands make have been so important to her.

Just like now.

She glances sideways, a sneak look, at Joachim. Her heart lurches at the sight of his profile. He does not seem to notice her change of direction, and he continues, as if floating, eyes directed upward, toward the cliffs. A great dream statue, he moves as if on wheels, destination predetermined. His long, looping hair covers his ears. His jaw is set solidly, hard, the judgmental mouth thin-lipped in its serious concentration. His eyes are once again hidden behind green lenses.

With her foolish flutter of love, pelvic or perfect, Carla thinks that if she were a man, this is who she would like to be. To him she attributes the power of detachment, the ability to be in the world but not of it.

Pulled along in his wake, she imagines how her days would be spent as him: witty, artistic conversation—perhaps the age-old debate of form versus content, or a rousing discussion of what, exactly, form itself consists of.

The Other Canyon

No one in your entire world would own a television, never mind think of watching one. If you decided to fly to Madrid at three in the morning, no problem. Every beach in the world would be waiting for you, every bottle of exquisite wine; every painting would speak to your soul; attractive women would gather around you in every port. The world would be a constant candy grab bag, delicious and exciting and available.

But you. Oddly, you would be somehow indifferent to it all. You would love the world while it was there, but you would never cling to the moment once it was gone. You would never fear the metallic machinations of public places. And you would not be afraid of other people.

Living inside the actual substance of time, your vision would expand and contract, a happy egg in the frying pan, coagulated and quiescent. The ink blot blooms in its calligraphied form on its damp sheet of watercolor paper, oozing joy.

But Carla is not Joachim.

She is only someone who happens to be walking next to him at this moment, someone he happens to have kissed.

She looks away from him and back toward the new canyon, the third canyon, where they are inexorably headed. The funny thing about walking here is that you keep imagining you are heading toward some actual place, some particular spot, when, in fact, it is the hollowness, the empty canyon, that you are aiming for. So what is the point of going any farther? They are already where they wish to arrive.

How do you say that in German?

They continue to walk.

Even though the sun is peculiarly intense and the depth of the canyon seems to dilate like an examined eyeball, by and by some of the sheer eeriness of the place seems to fade. Your body returns to consciousness as the dreamer returns to sleep. The certain world of practicality begins to gloss things over, an interesting state of double exposure. One time her mother took a photograph of a python in a cage in London. And the next shot she took was the very last image of Carla's father—but the film had run out. And the accidental cross-over, the random metaphor, revealed a weary man in worldly captivity. Before the squeeze of the snake.

Like a commercial break from her thoughts, Joachim's arm once again settles on her shoulder, the yoke of oxen.

And they stop, simultaneously, and gaze at each other. His Coke bottle eyeglasses shimmer like the Nile. Where, exactly, has this man been thinking?

As Carla stares at and then past his solid, handsome form, she sees an opening in the rock on the other side of the stream. Above the seeming entryway are more pictographs, but these are unlike the others—they are brightly painted, almost garish, far less modest than the group that caught her attention before.

Patricia Geary

Joachim turns his head to see what she is staring at, nods briskly, and then propels them toward this doorway. The flat of his hand is now on the small of her back, a possessive attitude Carla has always forbidden Michael but now somehow adoringly approves in this man, as though he, not knowing her, has somehow more right to possession: one of the great sexual illusions of perfect strangers. *The manacles of sex*, she reminds herself briefly before concluding that she doesn't care. As they walk across the bed of the graveled canyon, she is only wanting his hands to touch her, and she imagines that they are caressing each other already, already.

At the edge of the stream, they stoop and remove their shoes. Furtively, Carla watches to see Joachim's feet emerge from the high leather moccasins, as if they were presents being unwrapped, special gifts just for her. They are solid and square, his feet, the toes round and perfect as boiled onions. A thrill passes through her, shiver of the pelvis, when she sees that he is staring at her feet, pink and white and gold in the desert sun.

They exchange a look without language and step into the stream.

Platinum, her feet report instantly, their contact with the water jarring and sweet. *Gold*. And: *a little silver*. Her preoccupation with the man standing next to her has seriously fractured her attention, so only when she is literally standing on top of the metals does she notice them. Is this failure of her sensitivity a good thing or a bad thing? Hard to say, but at least the energy of the metals is good; nothing here is making her wary. Not even the necklace in her pocket. As she wades the inviting, icy stream, she feels the tranquility of well-worn objects: polished stone, broken-in leather, sun-bleached wood. The metals are used to this world and have grown essentially stronger. Like cacti and adobe, their endurance has toughened them even as they have faded. Where they might have been angry, they are only wise.

The metals are only wise, and they have only been here forever.

But then, before Carla can penetrate the center of this mystery, Joachim lifts her up in his arms. His chest is warm, damp, rusty. She wraps her arms around his neck, and her hands tingle. She watches his face, but it remains solid and unmoving, carved in wood. With slow, even strides they cross the stream.

Once out of the stream—Carla can feel the energy being muted through this other body—they head directly for what now appears to be the mouth of a rather large cave. Over the entryway dance brightly painted pictographs: dog-men with pointed penises, loops floating around the extended shafts like rings around Saturn, dancing goats with whole rabbit bodies for paws, bows and arrows that surround the enormous red and blue Spider Woman who welcomes them. Almost she nods and smiles as Carla and Joachim disappear inside the canyon wall.

Inside it is cool and musty, dripping limestone. Carla drops gently to her feet, and then they press their bodies together. Although Joachim is at

least six inches taller than Carla, his legs are short and hers are long, so his wonderfully hard penis presses into her lower belly; her legs automatically part, wanting to receive him, and yet this is all rather hasty, she has not thought what all this is about. She has not considered how reckless she is being. All she knows is that wetness swells from between her thighs, and the whole world has turned the same beautiful pink as the canyon walls—rose quartz and verbena, the pale pink of animal noses, or flamingo, coral streaks of sunset. The passionate tropics. A hidden shell, a mouse's ear, peppermint candy, the soft massage of the working heart. What she wants is to pull away the skin from her bones, and gently pull his skin away too, and then, oh perfect, they'd be *there*, connected by blood forever.

XVI

But their lovemaking is also very real.

Immediately Joachim's hand materializes between Carla's thighs, stroking her as if she were an expensive, beloved pet. Then his hand is beneath her clothing, inside her panties, inside of her. She pulls herself farther and farther apart, knowing from a great distance that this is not like her, she is confused, but just the same she moans. This is her. She is like this.

And then they are lying down, her bottom protected from the sand by his shirt. His chest is pale, square, smooth, with tufts of dark hair surrounding each nipple.

Now her sweatpants, shirt, and underwear are all being removed. Everything is happening very quickly. It must happen very quickly. All she wants is for them to be attached, as swiftly and completely as possible.

If God himself were to appear before her right now and offer her anything—wisdom, immortality, anything instead of this—she would have to choose this.

Joachim kisses the base of her throat. He eases his hands through her silky hair. His fingers are coaxing her deep inside, caressing her wider. By the kind, voluptuous, teasing way he plays with her, she knows that her body is beautiful to him. She opens her eyes.

Be a ravine to the empire, Lao Tzu's corniest advice. *Know the male, but keep to the role of the female.* It makes her laugh, and yet the connection is also the primal connection, the connection of opposite powers.

They stare at each other, moment of time-freeze. He seems to be made of some other substance than the skin and blood she is familiar with. His whole body seems larger, odd, unyielding as stone.

While their eyes remain interlocked, he carefully pulls his fingers out of her and licks them, as if they were coated with milk chocolate.

Soon, perhaps instantly, his penis is inside her. They press themselves against each other, and it feels so good.

Too good.

Like an underwater missile which has been previously programmed and cannot be diverted from its destination, he knows precisely where to take her. He insists on the direct route. And she forgets it all:

> her name
> the feel of the rocky ground beneath
> whatever time and space they live in

She forgets everything over and over and over again, and the only thing, between bouts of wanting and receiving, that remains clear is that it would be okay, just perfectly okay, to die now. Right at this moment. That would be fine, because nothing will ever again be the way that this is, nothing

The Other Canyon

will ever again be this powerful, and nothing will ever again set her this free.

You could die now.

Or now.

Or this time. The rusty smell of cloves, the ripe scent of skin and hair. The leather, the oil, the bump of noses and grinding of teeth. The light down on his chest and belly. The luminous white of his shoulders and buttocks, the pain of existence between your legs, the ache that won't stop through all the aftershocks of release, as if you were a container without top or bottom, and the water keeps pouring through, and each time you feel that you must hold all that, you must keep it there, but you can't, you can't ever be filled up, it will never be enough in this strange country you are living in.

Your body has dispersed into desert sand, always dry and porous, even in the middle of the cloudburst. Now you understand the sadness of the rock remaining rock. Now you will always long for this foreign land.

Inside the cave's ever-dimmer interior, your eyes meet now and again, the occasional spotlight in the perfect dark of the two bodies, matching parts.

If we had knives, platinum and sharp as logic, we'd kill us.

You wake up and everything has changed.

Black. As dark as the world has ever been. And someone else's skin is also your skin. But who is that? Who is there? Or maybe you are confused. Maybe you are alone—maybe you have never been so alone.

Carla groans. Something is sticking into her upper arm, and it hurts. Passion is over now. Now the odd stick or the chunk of rock becomes obvious. Shifting to dislodge this intrusive piece of debris, she awakens Joachim.

"Huh?" he says. "Are we there yet? Wait a minute, what time is it?"

Carla rolls back and snuggles against him. "I don't know. I—"

Wait just one minute! How come she can understand him?

She sits bolt upright. The air is chilly and dank. "I thought you didn't speak English!"

"I don't."

"So what are you speaking now? Swahili?"

"Don't be silly. You're speaking German."

"I don't know German."

"Don't put me on." And now he is sitting upright as well.

Carla opens her mouth to protest, but then her attention is diverted to the mouth of the cave, where a strange reddish glow has begun to emanate, flickering as if the world outside is on fire. Their bodies grow visible in this trace of light, the rounded slopes of shoulders and buttocks gleam preternaturally. Dramatically she extends her arm, an Athenian maiden-warrior pointing the direction with her spear.

"What is it?" His voice is hushed and respectful.

She responds inside with a trill of excitement. She loves the way his voice sounds; she loves the way he is. Maybe she knows nothing, really, about him; certainly, she has not yet grasped the nuances of his famous art form. But in another very important way she knows what he is. What his soul is like.

"Let's go see," she says.

He nods and stands up to get dressed. Carla stands up as well, brushing the sand off her legs and arms and hair. But before she can put on her clothing, Joachim's hand appears at the base of her neck. He draws her to him and kisses her forehead, sweet and kind. He brushes her fine blond hair away from her face, and for a moment they are all that there is again—yet that strange reddish light keeps flickering. Smiling, somehow sad, they turn away and resume the act of beclothing.

Soon their skin is mostly covered—how could they ever have been so naked?—and their clothing feels stiff and damp and dirty. They slip on their shoes and, hand in hand, walk out of their cozy cave and into the sharp won-

der of the night.

If the canyon was wondrous and exotic in the daylight, that beauty cannot begin to compare with this vision of the night-time canyon. The cliffs, as if composed of rosy phosphorus, glow of their own accord, or reflect the light from—what? The moon? And the river, too, shines as if it were illuminated from within. And, either because of or distinct from these strange elements, the valley is full of haunting music.

Carla and Joachim squeeze the hands they are holding.

Who is chanting?

Voices are singing a magical, tuneless song, and the painfully slow lament of the flute is following them. But it is difficult to determine which direction this music is coming from; all that can be seen is luminous landscape. The two travelers turn this way and that, and all they can see is cliff, water, and sky. The sky is velvet inky black, air redolent from the day's blooming flowers.

Then Carla turns back and gazes at the mouth of the cave. The great Spider Woman is watching.

Not singing.

Watching.

And this is the clue.

Turning once more toward the valley floor, Carla focuses her attention higher up on the canyon walls. And, sure enough, in the distance a pueblo is dimly visible, squarish buildings and the sparkle of several small fires.

"We have to go there," she says, indicating the pueblo.

"Of course we do," he agrees, and raises her hand to his lips.

Carla watches, and the emptiness cuts into her heart. They are bound together on this adventure, and nothing will ever again be the same. Their passionate afternoon can never return. Perhaps they will be together again, but even if it is wonderful, it will never be the same. All her life she has craved the security of sameness, she has shaped her security entirely around that pursuit, and now she sees, for the first time really and with absolute clarity, how false and foolish this aspiration is.

Everything changes.

Nothing remains the same.

As if Lao Tzu hadn't been pointing that out all along.

She is also sad because she knows that even this knowing of the fleetness of things is, well, fleet. Perhaps in another five minutes she will already have forgotten, will wonder, in fact, what it was exactly that she thought she knew.

And then, as Joachim returns her hand to her, she sees rather than feels the intensity of his ring. The ring, the heavy brass ring like an emblem of fiery repression, that she has been so conscious of. And she looks at her own hand and sees rather than feels the thin platinum chain which encircles her

wrist. *Is it gone then?* This power, the thing that has separated her from everyone else, the thing which has made her special. And different. And other.

Maybe this power is gone from her. Or maybe it was never there in the first place. What ever can the meaning be of anything that you can feel with your body? What can the meaning be of anything you can feel?

The way that can be spoken of is not the constant way.

They begin walking toward the glowing pueblo, shuffling along the luminous floor of the valley. The peculiar light and the atonal chant of unknown voices beckon them, and still Carla marches on, and still she wonders. And still she feels sad. Where were they only this afternoon? The country of sex, of skin that makes skin speak, is that another illusion? Soon, they will probably leave this place, and this other being with whom she has been so close, perhaps closer than with anyone before in her life (But then who could judge or remember? The saving power of sex is that it can blot the others out for you, make you forget what came before, virgin and dizzy once again)—why, she might never see him again!

How is that possible?

So sad, the great grief of everything.

And yet, what earthly difference does it make?

> One who excels in traveling leaves no wheel tracks;
> One who excels in speech makes no slips;
> One who excels in reckoning uses no counting rods;
> One who excels in shutting uses no bolts yet
> what he has shut cannot be opened;
> One who excels in tying uses no cords yet
> what he has tied cannot be undone.

One who excels in feeling ought not to think.

Soon they have traversed the distance between where they were and the pueblo. That's when the hair on Carla's arms begins to rise, the prickles of the extraordinary. Before they can even see clearly, she knows that this experience will not fit in with what she has previously known about the earth.

"I'm afraid," Joachim says suddenly. Then he laughs, a sort of rich chuckle. "I'm afraid of seeing what I pretend to believe in. What I've never actually seen. What I put in my films because—"

The chanting becomes louder; almost the words can be understood. Almost. Small, repeating waves.

"Because I want it to exist."

> O world one and original
> O world one and original

 The Other Canyon

O Zero World, O stainless land
O Zero World, O stainless land
The gods alone sustain you
The gods alone sustain you
Land of the humpback
The corn-eared dog
The red fish without gills
The ants that laugh at the moon
The three wings of rosiness
The heartbeat of ink

Carla puts a hand out to impede Joachim's progress. They stop and watch the figures sitting shadowy and two-dimensional before their enormous campfire. Their bodies, while clearly visible, are entirely translucent, an opalescent glass through which shines a distorted image of the world in back of them.

"Good Christ," says Joachim.

"God damn," says Carla.

Dancing bodies sway slightly like clothing in the breeze, float and glimmer in the rings of light. Singers are sitting in cross-legged clusters. Squaws are grinding corn, warriors are stringing bows, young ones are weaving baskets. Another group sits to the far right of the fire. Another group of luminous forms hunkers to the far right side of the fire, working away on shiny metal jewelry.

"Platinum."

Now it all comes rushing up toward Carla: the smell, the mental shape, the texture of this radiant element! Perhaps she has not lost her gift after all... The elegance of Bach, the suppleness of crepe de chine, the touch smell taste sound of what is truly refined as opposed to rarefied. The essence of what this earth can offer.

"That's platinum they're working with!"

"Who?"

"The jewelers, to the right. They're making platinum jewelry."

"Really?" he says. "How can you tell?"

"Well..."

Abruptly, the singing ceases. A large translucent figure, one of the singers, stands and faces out toward the glowing canyon, out toward where the two interlopers are standing.

"Come to us," the glowing form tells them. "You are welcome."

Reflexively, Carla and Joachim follow the motions of his beckoning hand, as if he had hooked them with an invisible, luminous fiber, and now, with each forward gesture, were reeling them in.

Forward they go, bodies intertwined, and then they climb up, up, up

the flimsy ladder made of lashed sticks, propped impossibly high and forever against the huge sloping sides of the cliff. Even though this has only before held ghost bodies, now it holds the all-too-solid flesh of the real world. But Carla and Joachim do not care. They no longer question the necessity of climbing. All they need to do is stay in motion.

Their hands grab the thin sticks and propel their bodies forward and upward. They are not afraid, and they do not expect anything. When nothing makes sense anymore, why bother to anticipate?

They hoist themselves up the last section of ladder, and then they are standing directly before the fire. The figures of the ghost people loom around them, still discernibly transparent and yet more brightly colored than they appeared from the floor of the canyon. You can see the sheer blackness of their hair, the airy reds and greens and yellows of their garments.

Only their jewelry is as solid as the rock in back of them.

The tall figure comes forward in greeting. His eyes, in their shadowy way, are an intense if transparent midnight blue. An old red blanket is wrapped around him. His hair is tied back in a long, thin braid from which dangle very corporeal, irregularly shaped silver baubles.

Very familiar beads.

Carla meets his eyes and her cheeks grow hot. Now she feels what she would not allow herself to feel at their last meeting.

But he holds his hand up in disavowal. If she has failed, he is telling her, it is no longer important.

"You are very powerful to have found your way to the Zero World," he tells them. "It is not a matter of luck. It is destiny."

Joachim nods with equal ceremony and dignity. "We are deeply honored to be here."

Carla is surprised. It had not occurred to her that he might understand this more than she does. For some self-centered reason, she had assumed that on one level, this was all for her—for her and the necklace. But now she realizes how much a part of everything he is, too. In the flicker of the fire, his profile is hard, almost cruel, the humorless expression of the willful seeker.

For one very clear moment, she sees how exactly alike they are, she and this stranger.

And then the necklace insists. She reaches her bare hand inside her pocket and pulls out the silver beads.

But what lies heavy in the palm of her hand is not the same necklace that she has traveled all this way to deliver! Instead of the crude, odd shapes, this piece of jewelry is strung with exquisite, miniature configurations, tiny animals and people, beads carved round and round with profound words of wisdom, stories of the meaning of life and the meaning of death.

Furthermore, this metal is not even silver.

This necklace, naturally enough, is made of platinum.

And now she wants it back! When she sees how unique, how lovely and precious it has become, she wants to close her hand around it and return it to her pocket. Her fingers tremble with the desire—and yet she manages to resist.

Palm spread flat, she makes her offering to the powerful old man, for whatever it's worth.

And he laughs with pleasure. "The Spider Woman's necklace!" he proclaims with delight. "How wonderful to have it back."

It remains between them, hovering on the sensitive pad of her hand. As if her vision has suddenly become as fine as that of a microscope, she can read the stories that the beads are telling her: they explain about the first world, Tokpela, Endless Space. And the second world, Tokpa, Dark Midnight, the world of silver. And the third world, Kuskurza, the copper world. And the world they have just left behind, Tuwaqachi, World Complete.

But the real story the necklace tells, beyond the gold and the silver and the copper and the now worlds, is the story of the platinum world, The World Without Concept of Difference.

XVIII

THE STORY OF THE ZERO WORLD

Before the world was ever conceived, there was nothing. The gods dwelt on their twin peaks, ruling over their beige and endless space, and they watched Spider Woman and The Man of Baubles, who eternally frolicked in their canyon home. They played The Game of the Forking Branch, Pigs That Never Sleep, Halt and Misstep, The Coral River That Leads Nowhere. They played Great Metal Shining Like the Moon, Squirrels and Otter, Many-Headed Willow. Protean shape succeeded protean shape, and sometimes Spider Woman would be The Strange Melon Which Cannot Be a Basket, or sometimes The Man of Baubles would be Sand Without Rust.

Day and night passed but they did not care, for their world was in constant fluctuation, sunrise and sunset meaningless because so easily ignored.

Spider Woman was always content, but one day The Man of Baubles began to grow restive. He was never as good at making up costumes, anyway.

He said, "Spider Woman, I am troubled. You love these baubles more than you love me."

Spider Woman replied, "You are The Man of Baubles."

"And what if I had no baubles?"

Spider Woman was busy fixing her feathered hat for the new game, The Turkey That Dispenses Acorns. So she hesitated, a slight furrow between her eyes, before she replied, "Then you would not be The Man of Baubles."

He shook his head and sighed.

"Have you made your Winged White Fish costume?"

"I do not feel like playing right now," he said. "I will take a walk in the canyon. By myself."

"How shall I amuse the gods without you?" she asked.

"They can amuse themselves for awhile," he said.

And off he went. Spider Woman looked up at the space around her and wondered at his discontent. She was very happy with this world, the zero land; was there something wrong with her for not growing tired of the games? The games were so beautiful, they were always changing, and she could be anything that she wished to be. She and The Man of Baubles could be anything that they wished to be together: he could be the shout in the dark and she could be the leaves that whisper. He could be the pulse that beats in your neck, and she could be the rock inside your pillow. Best of all, the gods were always watching them, and the gods were always amused. In what bet-

ter way could you spend your time than in entertaining The Duck Man, The Winged Buffoon, or The Hump-Backed Musician?

But The Man of Baubles did not agree. He looked at Spider Woman's raven hair, her body glistening like a plump squash, and he wanted all of her attention. He was weary of amusing the gods. What did they ever do for him, anyway?

He walked through the canyon that had been their home ever since he could remember, and he longed for a different place, a new place, dark and secret, where they could not be seen. He longed for one real and final change instead of the daily, hourly changes. These endless roles they played were nothing more than the same thing, over and over. Endless change is the same thing as stillness. He wanted the plip-plop of actual movement. He wanted the jump into sleeping peace.

But most of all, he wanted Spider Woman to tell him that whatever she did, she did it for him alone.

When he returned to their nest, his mate was amusing herself with a pair of boots fashioned from metal. The Man of Baubles approached her and said, "You are my woman."

"I am Spider Woman," she said, laughing. "I am neither yours nor not-yours."

Yet, something in her began to yearn that had not yearned before. Something in her grew warm and thrilled.

The Man of Baubles put his hand on her breast. "This is mine," he said. "And no one else may ever touch this." Then he put his hand down on the warm fur of her magic part. "And this is mine," he said. "These things do not belong to the gods."

Spider Woman was surprised, but she loved this man. "Okay," she said, placing her hand on his magic stick. "And this is mine."

And so, feeling dark and private, for the first time they made love inside the cave, where the gods could not see them. They made love day after day and night after night. And the gods grew bored.

"Bo-ring!" said The Winged Buffoon. "I wish they'd come outside and do that turtle routine with the bark tambourines. Now that was something to behold!"

Woman with Eagle Feet was throwing coins into an old felt hat, disconsolately. "I liked it when they made that miniature farm out of a cloud. Remember that?"

Cactus Angel nodded. "One of their best. How long can they keep this up? Aren't they getting tired?"

Down in the cave Spider Woman and The Man of Baubles were very far from being tired and bored. Because here, in secret, they had discovered the best game of all: when Spider Woman wished it, she could be The Man of Baubles. And he, when he wished it, could be her! Or they could both be

woman, or both man. With no one watching them anymore, or expecting to be amused, they felt the purest freedom. There was no real difference between them anymore. "You are my woman," they whispered to each other. "You are my man."

"This has got to stop," Tiger Warrior remarked some days later. "Enough with these two. Let's make us some new ones!"

"Good idea," Sunlight without Clouds replied. "But let's make them too tall to go into the cave—maybe nine or ten feet high. And green hair might look pretty good."

"Please," said Goat with Orange Forelocks, "don't make them too silly."

Someone grunted.

"Let's be more methodical this time," suggested the Humpbacked Musician. "Let's create a whole bunch of them. Then, even if some are in the cave, the rest will be amusing us."

"Bravo," they all agreed. "Way to go!"

And so it came to pass that the Flute Clan was created. They were a handsome, brave, noble race, and they afforded the gods much amusement. They built little houses of rock so that they could climb up and down the walls of their canyon home and still remain visible to watching eyes. They invented elaborate dances with masks and snakes. They learned to sing on and on, way into the night, luring the souls of all who listened.

And still, after all that, Spider Woman and The Man of Baubles did not come out of their cave.

"What's that racket?" Spider Woman asked one day, as they were drowsing in each other's arms.

The Man of Baubles merely rolled over and nestled into her. Today he was being himself, and so he had fallen asleep after lovemaking.

"Beans... corn... and squash..." Spider Woman repeated, echoing the scarcely audible chant.

What sense did that make?

"They're praising vegetables!" she declared, after listening a little longer. "But who are they?"

"You want me to go take a look, honey?" The Man of Baubles yawned. He was very comfortable, yet hadn't they been in there for an extremely long time?

"I don't know..."

Sighing good-naturedly, The Man of Baubles rose from their warm nest. He padded across the cave bottom to its mouth.

"Wait!" Spider Woman called, suddenly knowing the worst.

Too late. He was out of the dark and into the light.

The Zero World was over.

XIX

Carla shakes herself. Has she been dreaming? Her eyes are absorbing the intricate shape of a filigreed platinum necklace. They look up at the ghostly dark eyes of the strange old man. And then she remembers these things: glowing ruby walls, the feel of Joachim's hand between her legs, the magical pueblo which has come alive at night, full of inchoate forms.

Still, the necklace remains, distinct and tangible.

What was that story that I just told myself? Surely, that can't really *be the Zero World?*

Joachim nudges her, and then she breaks the gaze she has been sharing with the spirit world and turns to him.

Against the flickering lights from the otherworldly fires, he stands there, seemingly larger and more solid than the cliff rock itself. He nods once, importantly, as if to both reassure and confirm. From somewhere down in the lower strata of her heart—layers that she didn't know before that she possessed—a great outpouring of love wells up. For this perfect moment, she wants to reach forward and touch him, smooth the wild locks away from his brow, kiss the forehead with its light tracing of anxiety. She wants to rock him down into a sea of comfort, this whole other impulse of existence than the one that took them to just this side of pain and back, down there in the hot skin of the cave.

"Where did you ever get that necklace?" he asks.

She smiles at him, full of affection.

"Did you know how to bring us here?"

Carla makes herself remember because she wants him to understand. It is important that The Man of Baubles knows her heart. "A client of mine brought it to me."

His face looks quizzical.

"I read metal for a living. Jewelry, specifically. My client, Mrs. Renslop, brought it to me. She said her son found it in Chinle. But I thought it was, uh, stolen..." The foolishness of the whole story sounds in her ears, yet how can she be embarrassed in front of a half-materialized Indian and a German who makes films without actors? "I had a strange feeling about the necklace. I took a walk by the ocean, and a woman appeared behind me and told me to bring it back to her."

The Man of Baubles nods. "Spider Woman was anxious."

"How did it ever get away from her?" Carla cannot imagine Greg Renslop, the tennis pro at the John Wayne Tennis Club, ever making it inside this canyon.

"The old trading post. We lend out certain pieces so that the other jewelry can derive its power, spread out the energy. Metal ignites metal. The ele-

ments work on each other."

"Did your friend burn down that trading post?" Joachim questions coolly.

Carla feels tainted by her connection with the Newport clientele. For all she knows, that's exactly what happened. The singers, the rosy ghosts, regard her somberly—is she guilty by association?

The Man of Baubles shakes his head. "Local Anglos, pretending to be Hopi. They work hard to stir up trouble between the tribes. All the jewelry was looted and sold quickly out of trucks to greedy tourists."

Joachim nods, relief clearly visible on his large, square features.

Carla is relieved, too. And there's a message here, one that she'd best not forget, about the company you keep.

The Man of Baubles smiles now, and raises his beautifully transparent hands. Blue and green sparks of firelight shine through them. "But none of these details matter anymore," he tells them. "While this moment is now, it is also and forever not-now."

The lovers exchange looks like poppy and recollection.

The Man of Baubles holds the necklace, in all its delicate glory, aloft. "'The world had a beginning'," he tells his guests, "'And this beginning could be the mother of the world.'"

How odd, Carla thinks, as if this were any stranger than anything else that had happened recently. *He knows Lao Tzu.*

"'When you know the mother,'" Joachim continues, "'Go on to know the child.'"

"'After you have known the child,'" Carla offers, jumping in, "'Go back to holding fast to the mother/ And to the end of your days you will not meet with danger.'"

> Block the openings,
> Shut the doors,
> And all your life you will not run dry.
> Unblock the openings,
> Add to your troubles,
> And to the end of your days you will be beyond salvation.
> To see the small is called discernment.
> To hold fast to the submissive is called strength.
> Use the light
> But give up the discernment.
> Bring not misfortune upon yourself.
> This is known as following the constant.

The Man of Baubles laughs gaily, shaking his head as if to ward off the questions that keep bubbling to Carla's lips and then dissolving.

Patricia Geary 115

Joachim reaches over and takes her hand. He holds it hard and carefully. And the ring is no longer a problem for her. The old doors have closed, but the new ones have opened, grief and celebration.

"The cave walls," the ghostly figure directs them, sweeping his arms outward. Suddenly, from all the myriad cliff faces, the pictographs begin to twinkle even more brightly, as if they have been painted in Day-Glo. "That's the kind of wisdom they teach us. But, you know? I've lived with these ideas forever, and I'm still not entirely certain they hold water!" He laughs, deeper now, as if the earth itself were laughing, and the sparkling walls, the stories of Spider Woman and the Wheel and the Nave and the Something and the Nothing flicker and rotate like carnival attractions. They dizzy the eyes. And the music begins again, louder and more compelling, no longer the hypnotic chanting of the dreamer but rather the building rhythm of the dancer, the whirler, the primal dervish.

There is the story of the Illuminated Buffalo, the pelican who is his companion, the wristbands he constructs from the spines of gilded trout. He is a warrior, and the power carries him higher than the great twin peaks where the all-wise kachinas live. Carla and Joachim can see now how the cliff walls tell his story: the geometric signs which were previously so cryptic explain, precisely, how the story will unfold. Just as a musical score illuminates with andante or pianissimo, these symbols explain the tales.

Tale after tale, story after story—they are all unfolding, all whirling, all being explained on these canyon walls.

And one in particular holds their attention: a great wheel of whirling shapes over the cave where they trysted. The story that is being told—it's *their* story!

"'Metal Woman Meets Artist of Brass,'" Joachim recites, as if he were reading a movie title from a marquee.

And their tale opens before them:

How the necklace has brought her to the valley.

How a dream has compelled him to bring his film crew.

How she has left her Intended.

How he has disavowed The Woman Who Followed.

How the two lovers meet.

How they meet is all touch and timeliness. Carla feels it over and over, the rusty cloves scent all intermingled, the gravel beneath her bottom in the cave, the hot sun pouring down as they first kiss, the wafting dryness of this world, the smell of verbena, the riding thigh to thigh in the bump and wheeze of the army truck.

Does Joachim see exactly what she sees?

He presses her hand ever tighter.

Now read this part slowly, the geometric symbols explain. *Now feel the clean thrust of this knife. Feel it now. Here, you must pause and contem-*

plate. Imagine how you once were. Can you feel it more deeply now? Imagine there is no time. Now it is all happening as happened, happens, is ever-happening. Do you care now? Are you sorry? Would you ever change a minute of this, can you ever change a minute, will it always be like this, now and ever, just feel what your heart is speaking to you...

The ghostly shapes sigh and breathe, and the glittering pictographs whirl, and the glowing, rosy walls sing out, and the dark warmness closes down and holds you, rocks you, comforts you, and the air as sweet as the blood inside you.

XX

Joachim and Carla are walking along in what seems to be a pure, platinum tunnel. They also seem to have been walking for a very long time. Back and forward, there are identical vanishing points in the thick gray mist, which is neither warm nor cold. She will speak and he will nod, or then the other way around. They are not touching each other's skin exactly, but the texture of their conversation is touch, involvement, cause and effect.

"Ever since I can remember," Carla is explaining, her fine white hair shimmering against her shoulders, "what I feel isn't what others feel. I know it isn't. They'll see something, and explain it to me, but that wasn't what I was seeing. I was seeing this other thing all along."

Joachim nods. He doesn't need his sunglasses in here, so you can see how deep and intelligent his brown eyes are. The long strands of his snaky hair dance around his jaw like trees swaying in front of the cliff. "But I understand you perfectly. For me, you are not at all strange. You're the only one who's like me."

Carla smiles. She adores him.

"In my art," Joachim says, spreading his hands, "I try to make what is normal for me—that is, what is odd or abnormal or unfamiliar for the others—normal for everyone. That's why I picked Canyon de Chelly. In one way or another, I've been dreaming about it all my life."

Now Carla nods. Suddenly she realizes that she has been dreaming about it all of her life, too—there are those places you visit over and over again in the dream world. Do they all exist somewhere on this planet? The red walls that enfold you. The sweet metals of confidence. The hush of the dryness, and the storms of the elements.

"For Brecht," Joachim continues, "the primary distinction was not between things and human reality. He wasn't hung up on the difference between nature and social institutions. I didn't go filming that canyon because I wanted make some comment about society. Brecht wanted to talk about the difference between the static and the dynamic…"

Carla's hands begin to shiver. She knows that what he's about to say will be very important to her. This moment may be the reason they are in the tunnel at all, the cool-making calmness of the walls.

"…between that which is changeless, unaltered by time, and what is changed. What is historical."

She waits. What is he saying?

Joachim inhales deeply and spreads his arms even wider. "When you get used to something, when it becomes the normal or the familiar—then you think that the present is eternal."

Carla is right on the edge of getting this, poised at the brink.

"Whatever we live with becomes natural and, therefore, permanent. But when you make the familiar turn strange, then you show that what some-one thinks is changeless is really only historical. It isn't permanent at all. It can be changed."

Carla shakes her head, as if to dislodge that part of her brain which is resisting this idea.

"Well," says Joachim, "like your family or your house. They seem nat-ural because they are familiar. But they don't have to be."

Now an image is forming in Carla's mind: it's Monday morning and all those silk-clad ladies and cashmere-clad men are climbing into their expensive, metal contraptions and driving through the streets of Newport Beach. She can see right through this image now, as if there were a rent in the very fabric that makes this whole scene appear substantial.

"Okay," she says, excited, finally ready to hear it all.

"Now," says Joachim, winding up for the conclusion. "Take what is strange—and therefore subject to change—and make that a part of your everyday life. Eat with it, sleep with it, make love with it—"

They exchange deep and familiar smiles.

"—and you have really stopped time. Now there is only now. Now you are immortal."

The warm wine of understanding flows into Carla's heart. She tells her lover, "'Thus what we gain is Something, yet it is by virtue of Nothing that this can be put to use...'"

"CARLA!"

She shifts and mutters. Who is bothering her now? Who would ever find her in this perfect, shimmering tunnel?

"CARLA!"

Her left arm is numb. Her nose is buried in something sweet, soft, slightly oily. Cloves and rust? Her body jerks away reflexively, but an arm—whose arm?—wraps around her and snuggles her closer. "*Bitte*," mutters a sleepy male voice.

She opens her eyes to find herself, naturally, pressed against Joachim. But where are they? Where is the cave? Where are the ghosts? Careful not to disturb him, she shifts enough to see sunlight, rocks, and trees.

"CARLA!"

And that is Lucy's voice, concerned but progressing methodically.

"OVER HERE!" Carla yells back and Joachim leaps about three feet in the air. He opens his eyes, looks at her, and then, smiling, covers her mouth with his hand.

Carla laughs and he takes his hand away and kisses her. Immediately she forgets all about her worried friend. Her stomach and legs grow warm and pliable, and she leans into him as if he were the answer to everything.

"My God!" Lucy shouts, rounding the corner of the cliff and almost stepping on Joachim's foot.

They all stare at each other.

After the frozen surprise of the moment is over, Lucy's face begins to undergo an especially impressive sequence of expression. First: dumbfoundment. Then, sly comprehension. Then relief, exasperation, chagrin, and acceptance. "I'm sorry the truck took so long," she says. "It wasn't our fault. We didn't make it back until right before dawn. You know, the rest of the crew is still in that wash, filming! They said they'd seen you two go off, but when it got light and you still weren't back, well, then..." She trails off lamely.

Carla's face grows very warm. Fortunately, she seems to be wearing all of her clothes. She shrugs, half-hoping to dislodge Joachim's arm, which lies possessively across her shoulder, brass ring and all. But he remains heavily attached.

"Johnson is pretty upset." Lucy shakes her head, skin bronzed and glowing from the desert sun, green eyes sparkling, her whole body expressing alertness as the adventure, the wonderful adventure, continues. She glances back over her shoulder, toward the direction from which she has appeared. "I better go tell him I've found you. I guess he thought you'd been torn apart by wild wolves, or something."

Carla nods, still unable to muster an appropriate response.

Lucy winks. Since when is she a winker? "Get yourselves up and over to the truck, pronto. Just follow this cliff around to the right, and you'll see the wash." After a little nod to underscore the need for haste, Lucy vanishes as abruptly as she appeared.

Carla feels dazed. The sun beats down like honey—can it really be the next morning? Have they been out here all night... doing what? Her whole body aches, her back stiff from lying on the cold and stony ground; her thighs ache, presumably from lovemaking (that part she knows must be true); her head swells and pounds with the beginnings of a truly horrendous migraine.

A bird calls out soft and sweet, soaring overhead. She glances up, the clear bright air wafting the smell of verbena. And then she finally turns to look at Joachim, who has been patiently and solemnly staring at her all this time.

His brown eyes deep and intelligent, but she can no longer read what they are saying to her. They sit there, eye to eye, feeling each other's arms and shoulders, but they no longer know the words on each other's tongues. Perhaps for him this is merely one in a succession of one-night stands—Carla vividly and now, regretfully, remembers his technical proficiency, surely not purely the work of inspiration.

Or, perhaps, they are star-crossed lovers? Everything in their lives has directed them toward last night. And now the encounter is over. They will part, and never know again the true meaning of their existence.

And then, as Carla wonders what he can possibly be thinking, she hears, as if in a dream, the sound of his voice. In English. "'Take what is strange—and therefore subject to change—and make that a part of your everyday life. Eat with it, sleep with it, make love with it—and you have really stopped time. Now there is only now. Now you are immortal.'"

A faint smile softens the line of his jaw, as if he knows what she is hearing.

"*Ich verstehe*," he tells her.

"*Ich verstehe nicht*," she replies, the words leaping out at her from some unknown black hole of knowledge. *I understand nothing.*

His smile reveals another face, one that she hasn't known even existed. Suddenly he is boyish, almost innocent, his thin lips curving upward in merriment and delight.

"CARLA!"

Carla stands up and gestures toward her friend's voice. Brushing off her sweatpants, she tries to avoid bumping into Joachim, who is also standing up and whacking his seat to dislodge dust and gravel. Her limbs feel odd, as though not used to being attached to this particular body. Her hair is ridiculously tangled.

Sheepishly, Carla heads toward the exit direction, but a heavy hand pulls her back. And Joachim pulls her close to him, his sweet rusty odor, the

taut muscles of his arm, chest, thighs. For one pure moment her sadness is deep as a well; she is tumbling down a tunnel with no beginning and no end. When she feels him like this up against her, platinum wrist chains offer no advice or protection.

But then he is the first to break away, donning his bottle green glasses. Now he is as impossible to read as The Dead. He marches out the way that they have apparently entered—can it really be twenty hours ago?—and Carla follows quietly. Their hands are linked, but only just.

They round the bend of the cliff and stop. The whole great pinky sweep of the canyon in all its early morning radiance opens out before them like the arms of your mother. The shimmering river of metal. The cotton-woods. The sharp blue sky. Carla inhales one huge, verbena-laden breath, enough to send her up and into the ether. She knows she will never come back.

"COME ON!" Lucy shouts, so they obediently head for the truck, which is parked in the same place that it was the previous afternoon.

And nothing much else seems to have changed, either. Johnson stands by the cab, impatient, arms akimbo. Lucy is tan and excited. Dieter is still impeccably tidy, as if he spent the whole night standing up, and perhaps he has. Wolfgang, of course, is fooling around with the equipment.

Solange is resting on one of the benches in the back of the truck. She lies face-down, her forearms cradling whatever her expression might reveal.

"Now we are going," Johnson remarks accusingly as the two stragglers wander up.

But then the expression on his face changes. For a moment, he seems to see them truly, and his entire face is filled with such love and respect that Carla knows she must be hallucinating from lack of food and water. He looks strangely similar to that old Indian in the diner. But then, wasn't that a dream? Or did she see him again?

Blink and his face changes back. "Now we are going," Johnson insists.

So they all climb back into the truck and resume their old positions. The vibration is cold, vaguely threatening, but Carla no longer cares. What difference does anything make? She averts her eyes so that she will not have to speak to Lucy, not just yet. Wolfgang and Dieter greet Joachim in German, but he does not reply. Gently shaking Solange awake, he extracts a cigarette from her. She sits up, combing her white fingers through her auburn hair, her cobalt blue blouse falling open at the neck, revealing the tops of her large, white breasts.

Carla feels nauseated.

Johnson starts the motor and Joachim settles in between Carla and Solange, touching neither one. He lights his cigarette and inhales like a pro-fessional, like Philip Marlowe after cracking the case. In his rumpled black poet's shirt and dusty cords, wily tendrils of hair framing his face, he is cool-

The Other Canyon

er than ever.

And even more remote.

Carla sighs and leans her shoulders against the back of the bench, her neck stiff and tense. Tonight they will stop halfway home, she tells herself, and stay at a nice hotel. They deserve the extra day. As if it were a litany, she recites what she must be longing for: Perrier water with lime, a soft bed with perfumed sheets, a bubble bath...

But she can trigger no joy by recalling these things. All she feels is a black inky hole where her heart is supposed to be.

She will break things off with Michael. In her heart, she knows he will be more relieved than surprised.

"What did you do with the necklace?"

Lucy's question jolts her away from her thoughts.

"Could I have some water?"

Lucy hands it over. "But what did you do with the necklace?"

The cool liquid goes down her throat like the secret to happiness. "I don't know." Carla's head feels like it's muffled with bandages. The headache is staying away, but everything is padded, vague, the hard edges protected. "I thought you had it."

Lucy stares at her, face suffused with concern as the truck jolts and lurches along. "Don't you remember? I left it in the truck when I went off with Johnson. You said you'd take care of it. And it isn't here."

Now Carla's brain feels murky and bruised. Images come and go like ghosts momentarily issuing from the grave. Here's an odd shape now, a pair of navy eyes—but when she tries to recall who, what, or how—it all disappears, thinner than air, paler than memory.

"Think hard," says Lucy. "Drink some more water. Eat this." She hands Carla a protein bar.

"No, thanks. I'm really not hungry."

"When I left, you were over by those pictographs. When I found you, uh, asleep this morning, you were with your buddy. Spare me the personal details, but what happened?"

The shape of some sort of powerful woman appears in Carla's misty thoughts. As soon as you begin to grasp, that shape is gone. "What pictographs?"

Lucy sighs.

The image returns: Spider Woman! The name appears in Carla's consciousness like a stone thrown over the wall from another dimension. *Spider Woman.*

And then: The Man of Baubles. *The Man of Baubles.*

The truck lurches violently, as if to dislodge her memories.

And the slate is blank again, like an Etch-a-Sketch after you shake it. Almost it was there—the faint outline remains. And when she tries to think of

last night with Joachim, she can only recall that he followed her. She knows that he made love to her—her body-memory is a delicious spasm of muscle—but where exactly or when, she cannot say.

And what does it matter, anyway? Right now he is turned away from her and toward Solange, conversing quietly in German, probably explaining how last night was just a fling, it meant nothing. Probably, they are both used to these little episodes.

Solange begins to weep.

"Come on," Lucy urges. "Did you take the necklace out of the truck or didn't you?"

The sun is hot already and Carla's skin throbs in pain. "Yes!" she blurts suddenly. Her hand recalls the touch of the metal. Distinctly, it is the hand and not the mind which has the power of recall. Her fingers flex, grasping to remember the rest. And it *is* there, shimmery and surprising as the first snowflake. Or the moment that the tide actually turns—which you can feel in the air, standing in front of the ocean, if only you are quiet enough. You can be allowed to feel that.

Solange's sobbing grows louder; she is approaching the edge of hysteria. Joachim places a tentative hand on her shoulder but she shrugs it off.

"Well?" Lucy presses.

Carla looks up at the great pink walls of the cliffs, which they are rapidly, so rapidly, leaving. The sky is sharp and blue as your first good-bye. Then she glances at Joachim, and he catches her gaze, his handsome and impassive face turning toward her. With the green circles over his eyes, he is seemingly unreadable. But he nods, with confirmation, before attempting once more to comfort Solange.

And then Carla's hand tingles: her hand knows perfectly, for this very moment, the feel of the platinum necklace and all of its stories.

You see a shower of red, yellow, and green fireworks.

You see the strange revolving wheels of the pictographs.

You see her story.

You see their story.

Carla smiles at the intelligent, anxious face of her friend, her good and beloved friend. "I remember now," she says quietly. "We just walked down past the cliffs a little bit and offered the necklace back to the canyon. It was fine, just the way it was supposed to be."

Lucy opens her mouth to reply and then shuts it again. Her forehead squiggles thoughtfully. She is a mask of understanding.

The Other Canyon

XXII

Hours later the truck pulls up in front of the Spider Woman Lodge, a weary and disoriented crew. Carla is sunburned and stiff, and there is a sad hollowness in the place where her heart used to be. She has spent the return voyage idling and dreaming, hoping and forgetting and remembering nothing; the past is as useless to her as the future.

"I can't believe how a bath is going to feel!" Lucy announces as she stands up, shaking the trail dust off her lederhosen. Her clothes look the same as they did over twenty-four hours ago. There is something to be said, after all, for this silly garment.

Wolfgang and Dieter begin to organize and examine the pile of metallic spiders that has passed for camera equipment. Who even knows if it is actually functional? The whole ordeal might have been a piece of performance art. Solange is looking extremely unhappy, and Joachim is solicitously helping her disembark. They are both smoking cigarettes.

Carla climbs down off the truck, her feet aware of the release of pressure as soon as they touch the solid ground. Something here, some special energy, has been waiting for her, and now it welcomes her back. With one last nostalgic image of the great pink arms of the cliffs, surrounding you and protecting you, she gives in to the new energy, and allows her tired and ruffled nerves to be soothed.

"I'd like brunch at Las Brisas," Lucy says, gazing around in an abstracted manner. "And you better believe we're staying in the Phoenix Hilton tonight!"

Carla conjures up an image of Las Brisas, one of those seaside, Orange County, alleged Mexican restaurants so elegant that it might as well be French. All that food so handsome and expensive, tiny little sticky buns and apricot muffins no bigger than walnuts. There is seldom a tortilla in sight. A spasm of revulsion traces down her spine.

Michael loves to eat there. She will never be with Michael again.

Perhaps she could become a missionary and sail to Indonesia. Except that she is not particularly religious, and she doesn't believe in converting people. Well, then, where shall she go? After all, she has plenty of money in the bank. Money has never been the issue.

She's been lucky that way. And yet, she no longer wants to be the person she has been. How will she find the courage it takes to give herself open to remembering?

Idly, as Lucy begins her farewells to the surly Johnson, Carla regards the platinum chains around her wrists. Does she need these anymore? Feeling warm, she pushes up her sleeves. And there, on the back of her left hand, is a small and perfect image of The Man of Baubles.

She stares, hypnotized by the exquisite, miniature image.

And then, next to her hand, another hand appears, a large and square masculine hand. On the back is an image of Spider Woman herself.

Carla looks up and meets Joachim's eyes. His sunglasses are off, and she reads a cool and distinctive face with a heart full of longing.

He pulls his phrase book out of his pocket. Riffling through, he finds his page. "Vould you like to go vit me?" he asks her in his heavy German accent.

They exchange looks like the poppy and the dream. And then Joachim glances over his shoulder, and she follows his gaze. The film crew are climbing into a silver van and loading equipment.

Next to the van but pointed in the opposite direction, the large maroon American car is waiting.

Carla nods solemnly. She holds up a finger to indicate that he should wait a moment, and when he nods with understanding, she approaches Lucy and taps her on the shoulder. "I'm going away for a while," she says. "I'll go get my stuff out of the room. You can have the Mercedes."

Determinedly, she enters the room and throws her things into her bag. Pulling some stationery from the desk drawer, she jots down a note to Michael, the one she has been composing in her head all morning. Oddly, she realizes once again that he will be more relieved than surprised. She seals and addresses the envelope, and then she writes a note for Mr. Powell.

When she returns outside, Lucy is still standing there in shock. "Could you drop this in the mail for me?" she asks, handing her the letter for Michael. Then she removes all of her platinum chains. "And Mr. Powell will give you a really good price on these. Call up a moving company and have my apartment packed up and put into storage. I really appreciate this. There should be plenty of money left over, and you can have that. And here are the car keys," she adds, handing them over.

"But, Carla!" For once Lucy is beyond her customary expressions. "Why?"

Why, indeed?

Johnson is still standing there and he studies her shrewdly. Then he glances pointedly back to where Joachim is still waiting, eyes opaque once again behind round lenses. "The fresh air can have a strange effect," he tells Carla, smiling. "Different air, different dreams, different futures."

And before she can respond to that, he turns back to Lucy. "How about giving me a ride to the coast? I could use a break from the desert."

Lucy's face flushes with pleasure.

Carla hugs her dear friend good-bye. "Thank you," she says. "Thank you so much." She is sorry to leave her, and for a moment she thinks she is making a terrible mistake.

And then Lucy smiles. "Don't worry," she says. "I'll handle every-

thing. You just take care of yourself."

Now Carla turns toward the dark form of the man who is waiting for her. Wordlessly, in the bald heat of the sun, they load their bags and climb into his car.

The vibration is so exotic that Carla catches her breath. For a moment the lack of her chains surprises her, and then she knows that she no longer needs protecting.

Joachim raises his hand in farewell to his crew, who stonily watch him depart. Dieter is in the driver's seat of the van, Solange is next to him, and Wolfgang is loading the equipment in back. When the big American car pulls away, Wolfgang looks up and smiles.

Carla waves to him, and then to Johnson and Lucy, who are standing next to each other and smiling. Johnson is nodding and Lucy looks happier than Brian might care to believe.

And the two travelers pull away. A little parade of the earthly pleasures of her life in Newport Beach dances across the floor of her mind: the beautiful clothes hanging freshly ironed in the closet, the clean scent of early morning flowers, pansies and primroses, pate with truffles, and a chilled glass of Dom Perignon. Everything manicured, everything exquisite, everything in its proper place.

But then she glances at the stern profile of the man beside her, feels with a kind of muscular trill the press of his body. And, as if reading her thoughts in the desert air, he places his hand tenderly on her thigh. The warm brass of the ring burns pleasingly into her.

And the road pulls them on ahead.

Where are they going? Where have they been?

Carla only knows that this is it, now, the moment of her life.

> To know yet to think that one does not is best;
> Not to know yet to think that one does will lead to difficulty.
> It is by being alive to difficulty that one can avoid it.
> The sage meets with no difficulty.
> It is because he is alive to it.

Carla, enjoying the tingle of completing the circuit as her body touches his, extracts the phrase book from Joachim's pocket. Already they are past Chinle, heading east. Perhaps they will go to New Mexico, the Land of Enchantment.

"*Sehr erfreut*," she tells Joachim.

He smiles and takes the phrase book, flipping through as he steers with one hand. "I am pleeze to meet you," he responds after a few minutes.

What do they know? They both gaze ahead, traveling out over a dry, vast, endless space. The sun and the silhouette.

Patricia Geary 127

About the Author

Patricia Geary teaches at the University of Redlands and is the author of two highly acclaimed novels, *Living in Ether* and *Strange Toys*. She also practices yoga in Redlands, California, where she lives with her husband, Jack, and son, Denis. *Strange Toys* is the winner of the 1987 Philip K. Dick Award.

About the Artist

Penny McElroy is an artist who lives and works in Redlands, California. She actively exhibits her work throughout the United States and abroad. Her recent artist's residency at Casa Don Miguel in Patzcuaro, Mexico was a source of inspiration for the images reproduced in this book.